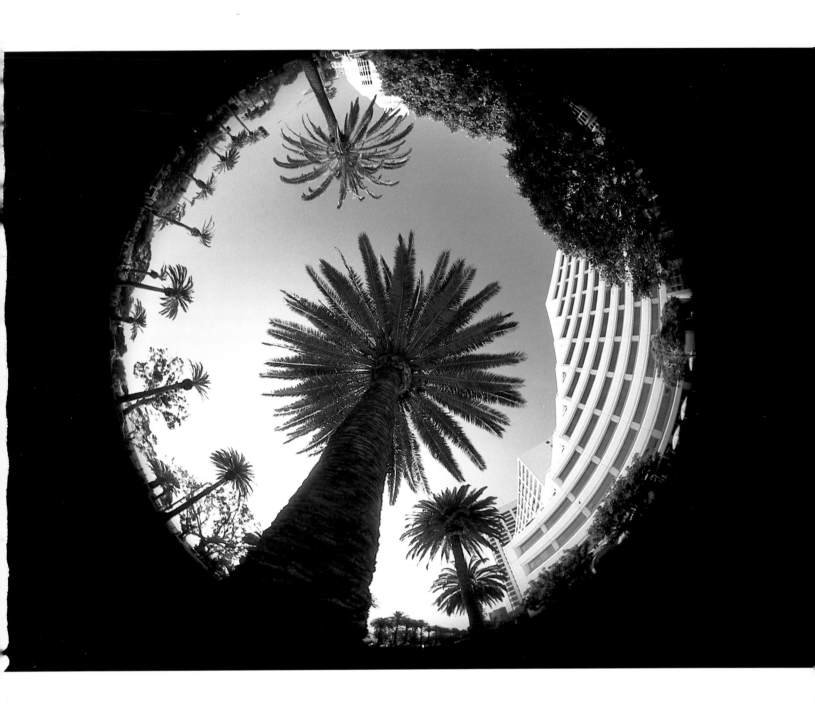

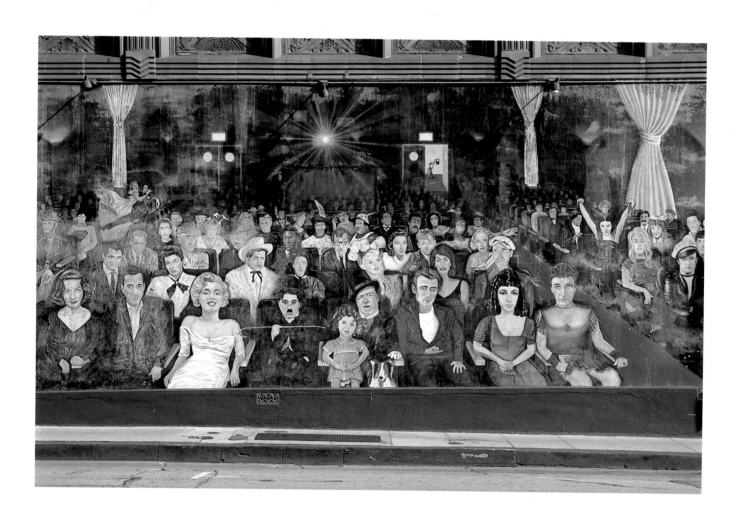

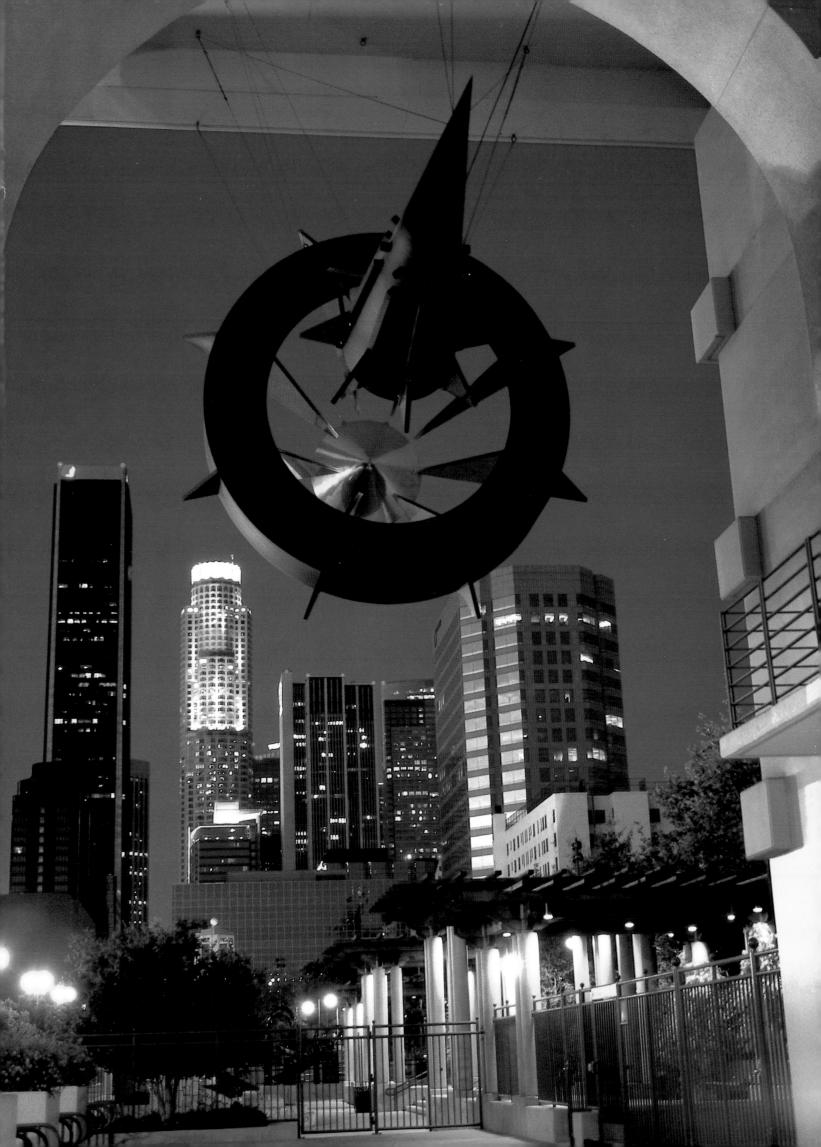

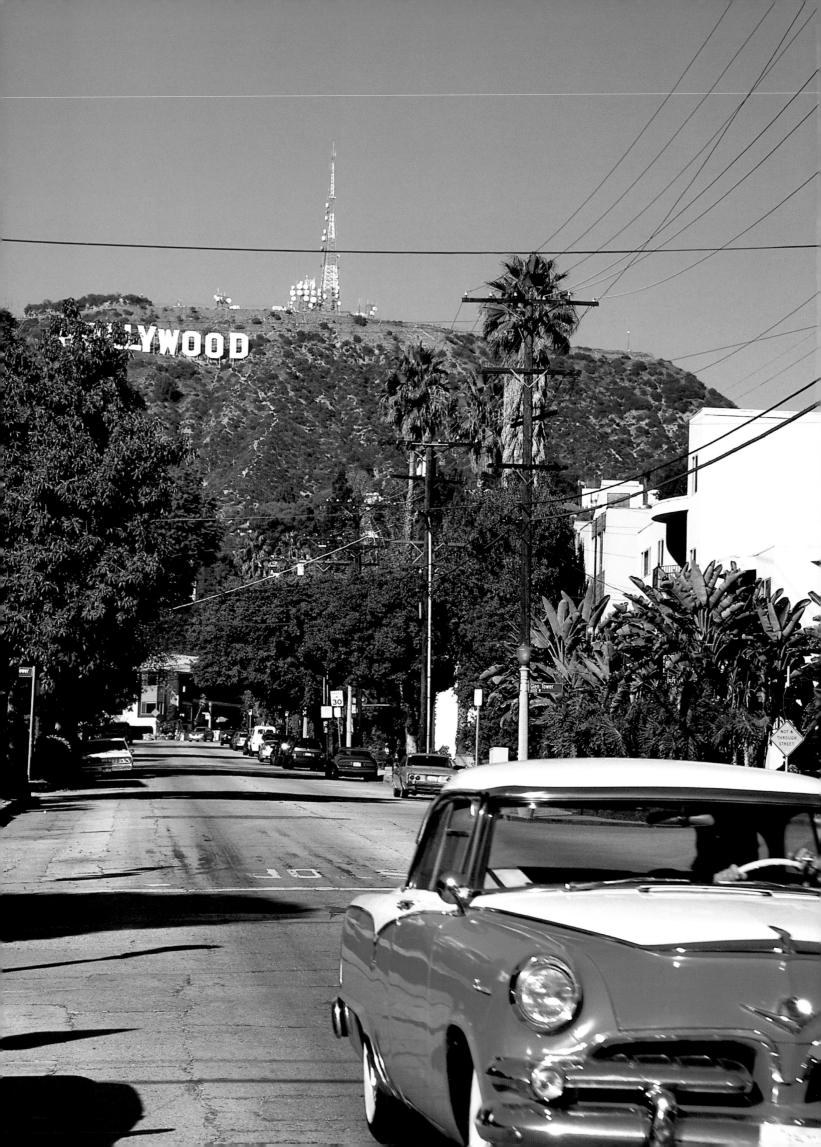

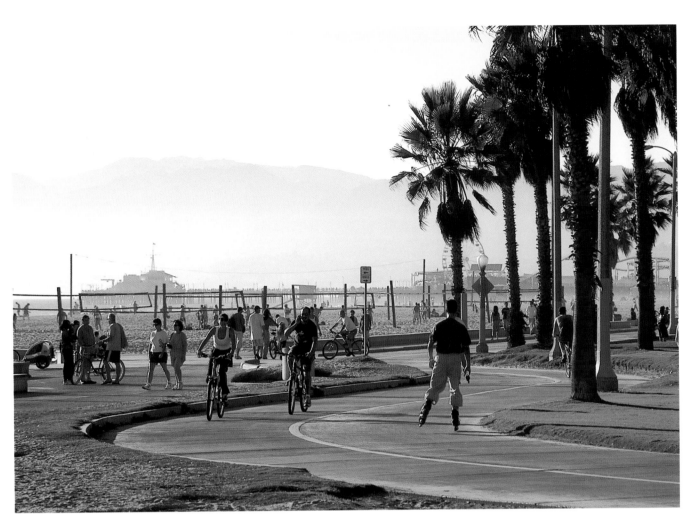

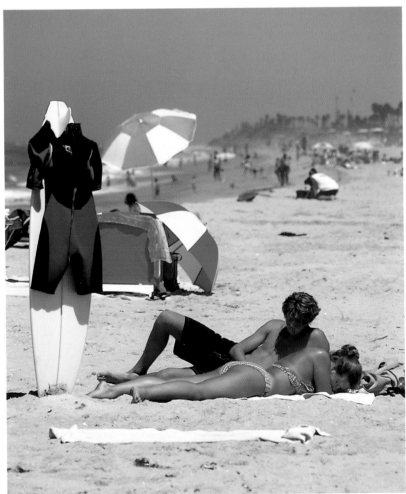

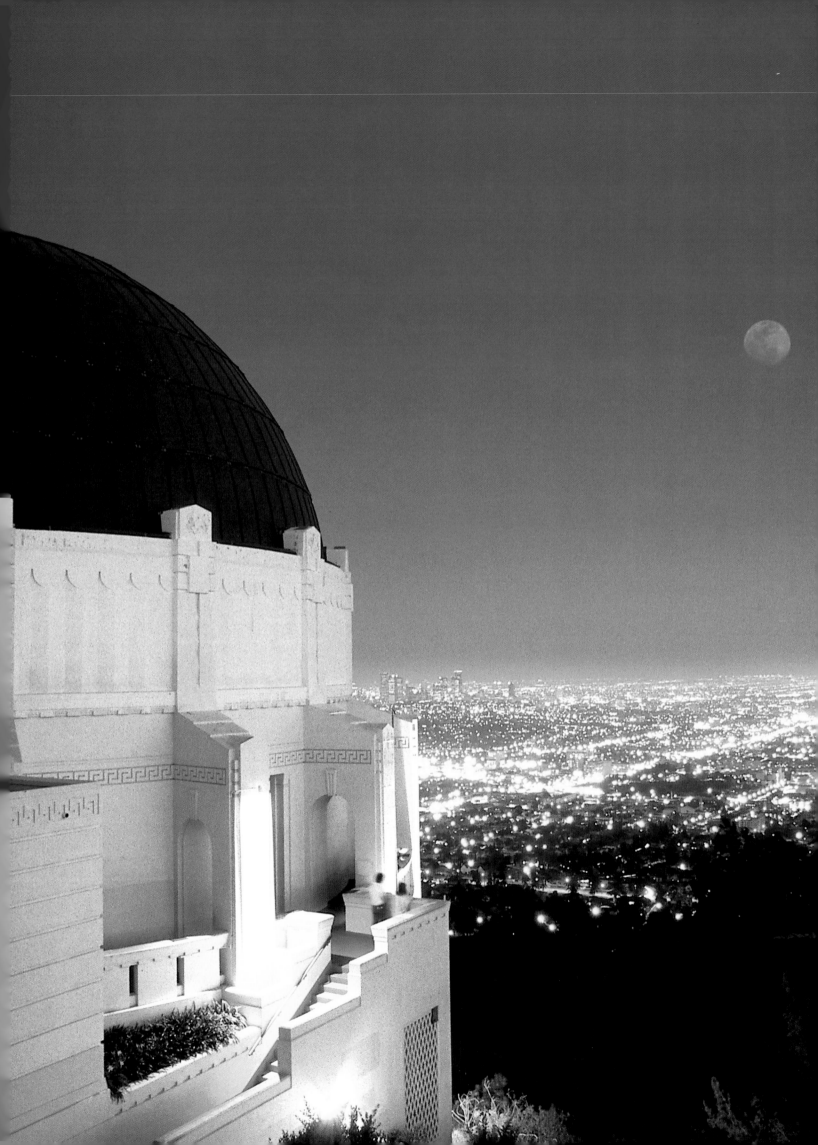

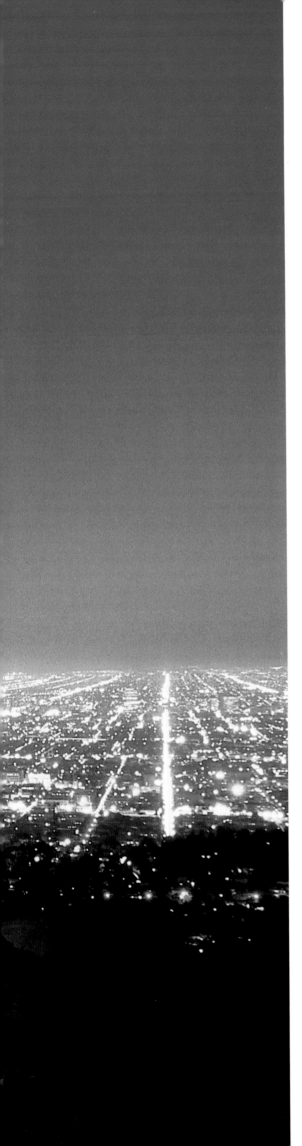

Only in
Los Angeles

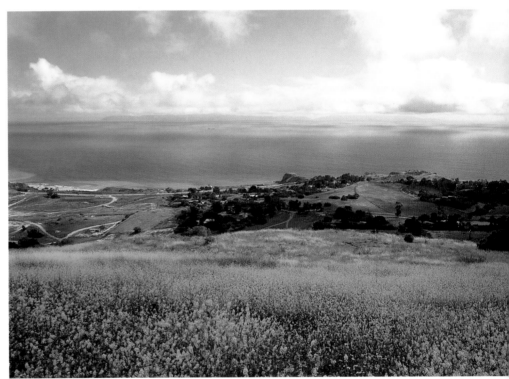

Photography by Ambient Images

Voyageur Press

Edited by Josh Leventhal
Printed in China

04 05 06 07 08 5 4 3 2 1

Library of Congress Cataloging-in-Publication Data

Only in Los Angeles / photography by Ambient Images.
 p. cm.
 ISBN 0-89658-660-X
 1. Los Angeles (Calif.)—Pictorial works. 2. Los Angeles (Calif.)—Social life and customs—Pictorial works. 3. Los Angeles (Calif.)—Description and travel. I. Ambient Images, Inc.
 F869.L843O55 2004
 979.4'94054'0222—dc22
 2004012603

Published by Voyageur Press, Inc.
123 North Second Street, P.O. Box 338
Stillwater, MN 55082 U.S.A.
651-430-2210, fax 651-430-2211
books@voyageurpress.com
www.voyageurpress.com

Educators, fundraisers, premium and gift buyers, publicists, and marketing managers: Looking for creative products and new sales ideas? Voyageur Press books are available at special discounts when purchased in quantities, and special editions can be created to your specifications. For details contact the marketing department at 800-888-9653.

Page 1:
Towering palms line the famous stretch of pathways and greenery known as Palisades Park in Santa Monica. *Larry Brownstein/California Stock Photo*

Page 2:
Bogey and Bacall, Taylor and Burton, Marilyn, Marlon, Woody, and Charlie are just a few of the stars featured in Thomas Suriya's *You Are The Star* mural, which decorates a building on Hollywood Boulevard in Los Angeles. *Larry Brownstein/California Stock Photo*

Page 3:
The courtyard of the Renaissance Tower at Grand Hope Park—home to the Museum of Neon Art—frames the Los Angeles skyline in a golden glow. *Richard Carroll/California Stock Photo*

Page 4:
The famous Hollywood sign looms above LA's Beachwood Drive. The classic fifties car recalls a golden age of Hollywood. *Peter Bennett/California Stock Photo*

Page 5, top:
Surrounded by palm trees and miles of open ocean, Santa Monica's beachside bike path is often teeming with bicyclists and rollerbladers out for some exercise. *Peter Bennett/California Stock Photo*

Page 5, bottom:
Surfers take a break to soak in the sun at Huntington Beach, one of many pristine stretches of sand along California's acclaimed Orange Coast. *Richard Carroll/California Stock Photo*

Page 6:
Griffith Observatory, tucked high in the Hollywood Hills, provides a spectacular vantage point from which to view the bright lights of the City of Angels. *Larry Brownstein/California Stock Photo*

Page 7:
Much more than just urban sprawl, the Los Angeles area offers a plethora of natural beauty, such as the rolling mustard fields of Rancho Palos Verdes. *Larry Brownstein/California Stock Photo*

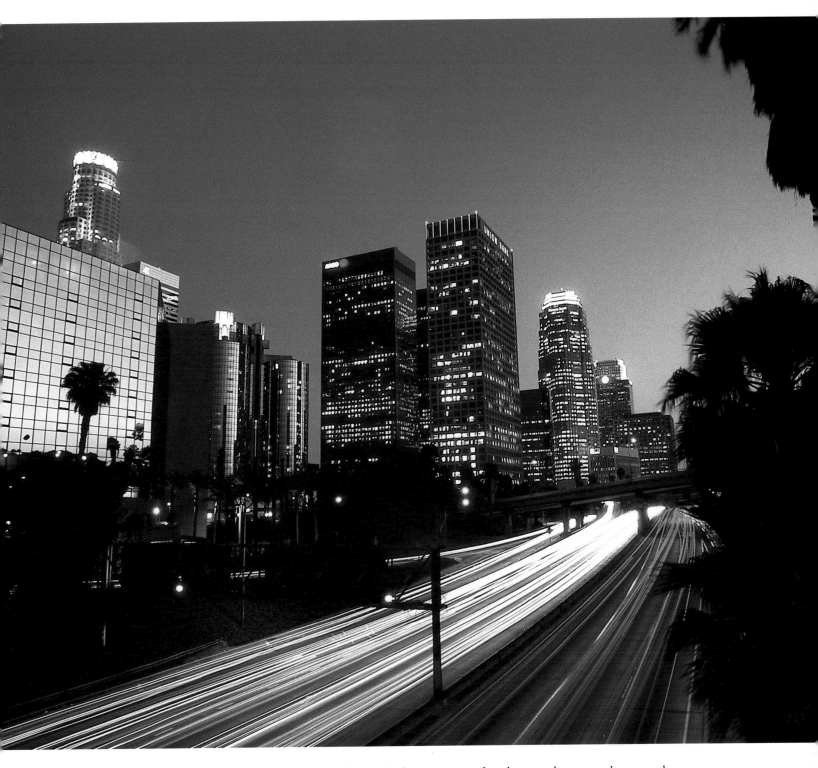

Traffic surges into the heart of Los Angeles on six-lane highways twenty-four hours a day, seven days a week.
Richard Carroll/California Stock Photo

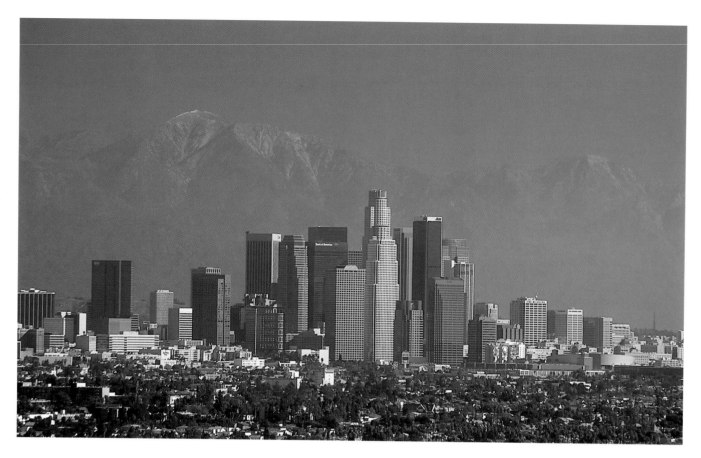

Above:
The San Gabriel Mountains are faintly visible beyond the towering skyscrapers of downtown Los Angeles. Between this inland mountain range and the ocean to the west live millions of people in many diverse neighborhoods. *Peter Bennett/ California Stock Photo*

Right:
The moisture-laden ocean air and the surrounding mountains trap LA's infamous smog, which blankets the city most days of the year. *Larry Brownstein/California Stock Photo*

Facing page:
Designed by Spanish architect José Rafael Moneo and completed in 2002, the Cathedral of Our Lady of the Angels is both a spiritual gathering place and a stunning architectural attraction. *Larry Brownstein/California Stock Photo*

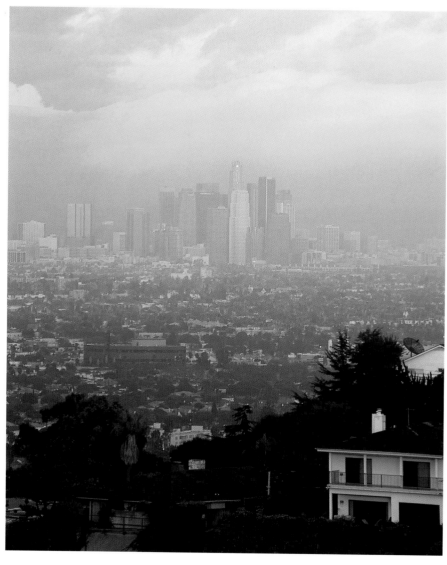

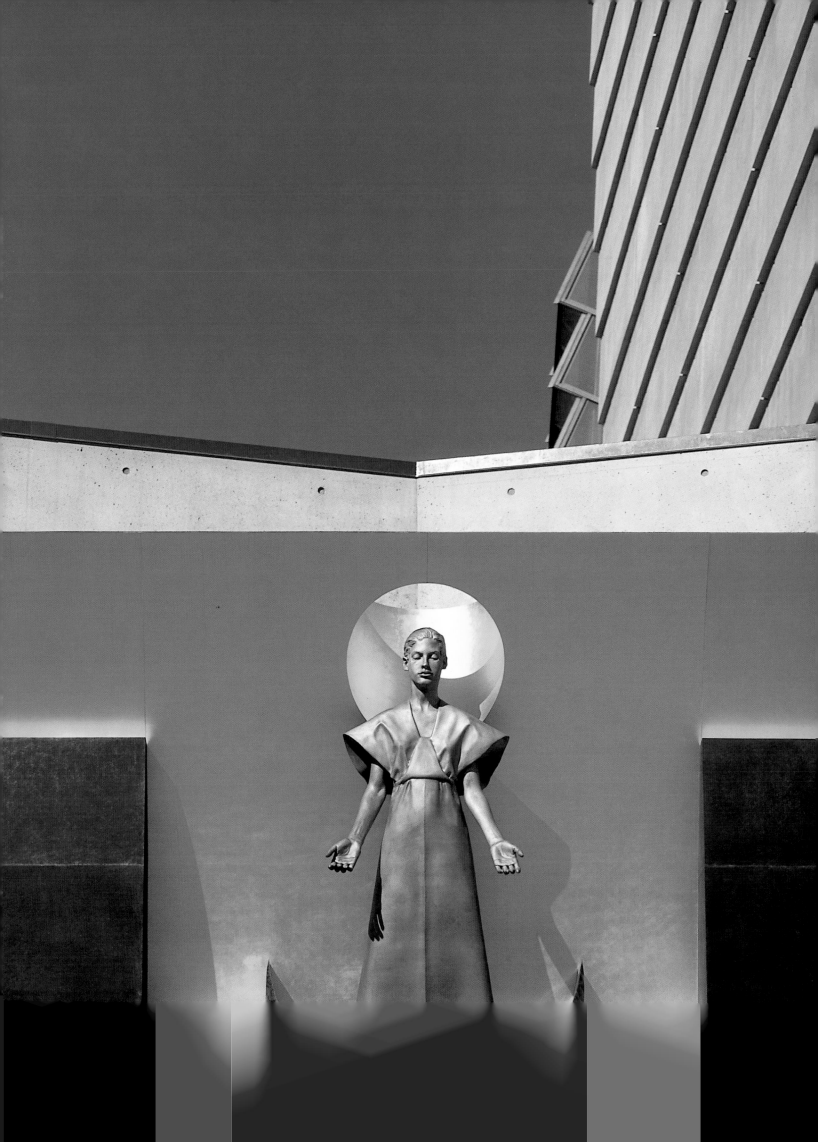

The Eastern Columbia Building has been a Los Angeles landmark since its unveiling on September 12, 1930. Designer Claud Beelmen embraced the art deco style popular at the time, incorporating sunburst patterns, geometric shapes, and stylized animal and plant designs into the stately thirteen-story structure. *Larry Brownstein/ California Stock Photo*

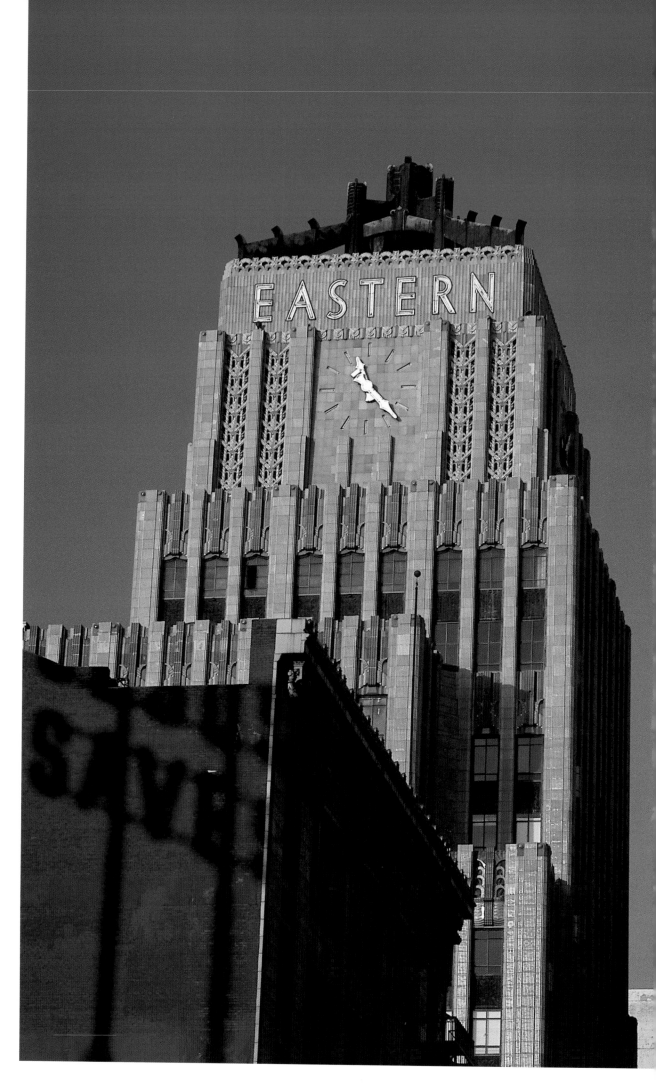

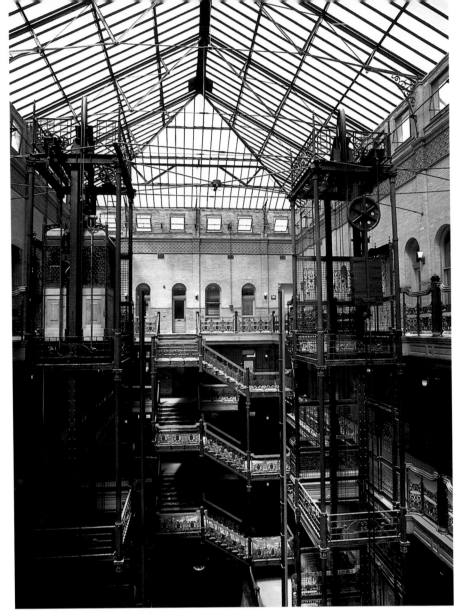

Left:

The Bradbury Building in downtown LA remains a notable architectural achievement more than a century after its construction in 1893. Commissioned by millionaire Lewis Bradbury, amateur architect George Wyman found inspiration for the design from a science-fiction story. Fittingly, the futuristic atrium, with illuminating skylights, appeared on the big screen in the classic sci-fi thriller *Bladerunner. Richard Carroll/ California Stock Photo*

Below:

Created in 1866, Pershing Square is the oldest park in Los Angeles, though it has been redesigned several times in its long history. After years of neglect, the park was refurbished again in 1994 with the addition of a fountain, café, and bell tower. *Larry Brownstein/California Stock Photo*

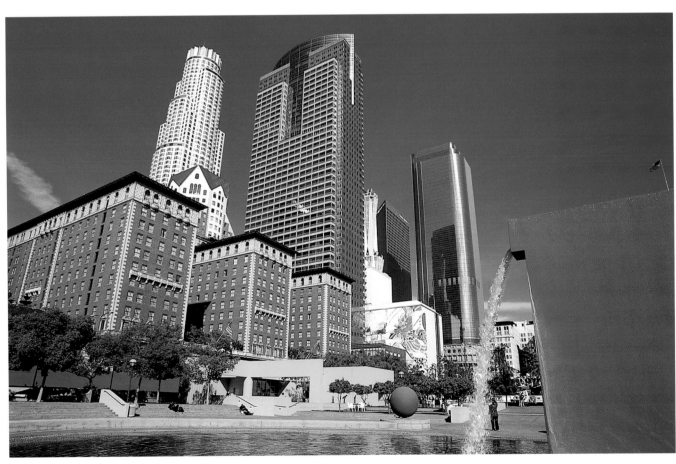

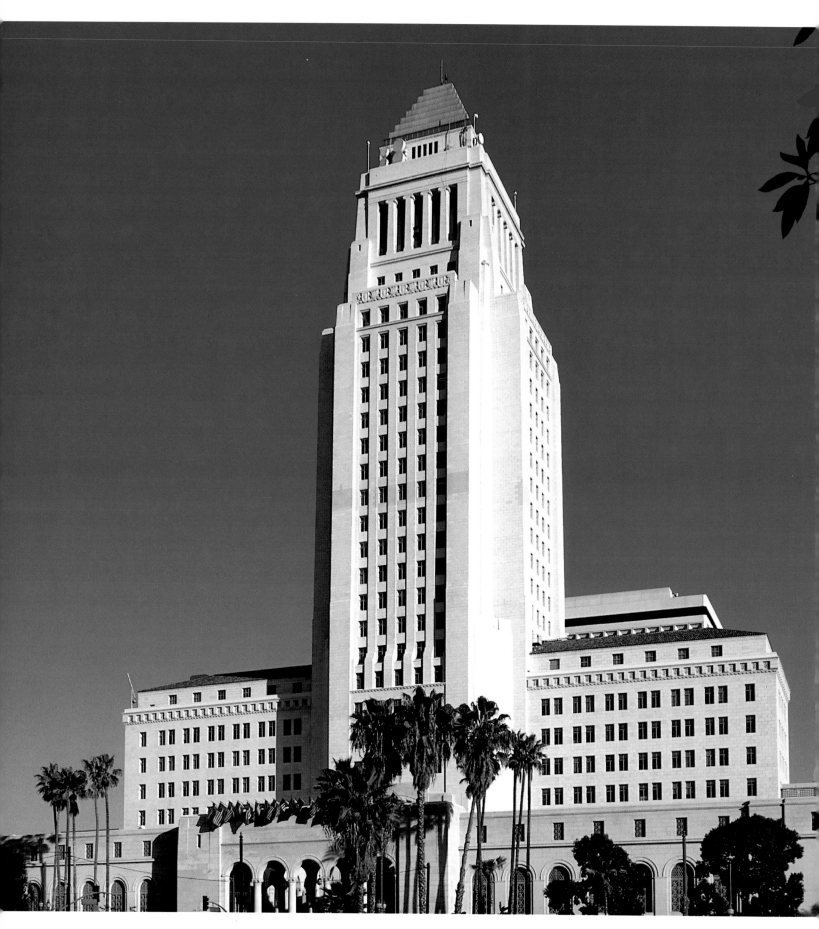

The Romanesque Los Angeles City-County Civic Center, faced with light-gray granite and terra cotta, stands tall against the brilliant blue California sky. The historic building is home to city, county, state, and federal offices. *Peter Bennett/ California Stock Photo*

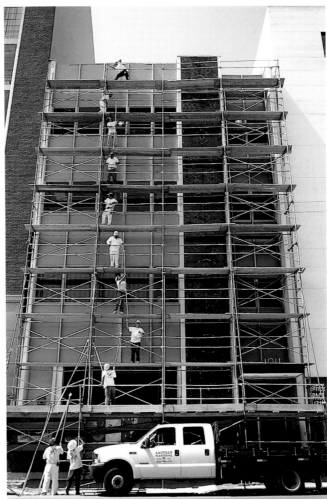

Already the second-largest metropolitan area in the United States and home to thousands of businesses, the city of Los Angeles continues to grow and expand. Here construction workers form an assembly line to erect scaffolding around a downtown building. *Larry Brownstein/ California Stock Photo*

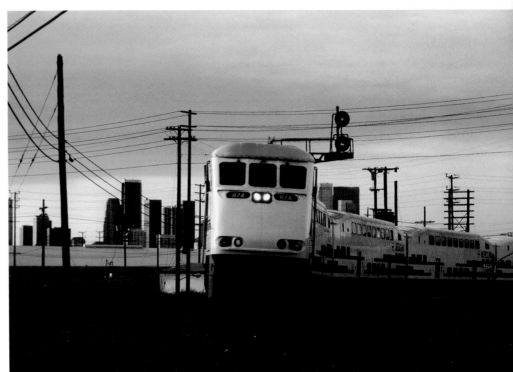

Los Angeles launched its commuter metro-rail system, Metrolink, in 1992 in an effort to ease traffic congestion and pollution and improve the quality of life. Planners expect it will take thirty years to build the entire network, which will encompass 300 miles of track. *Sean Zwagerman/California Stock Photo*

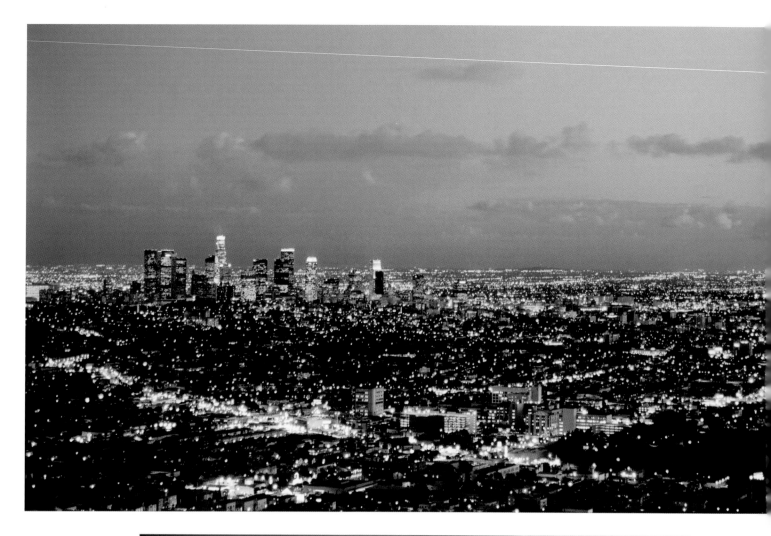

Above:
The glow of city lights illuminates the avenues, businesses, and homes, and defines the sprawling grandeur of the Los Angeles metro area. *Peter Bennett/ California Stock Photo*

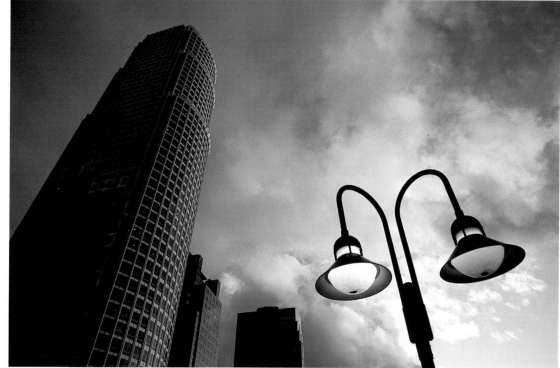

The U.S. Bank Tower, originally called the Library Tower, is the tallest building in Los Angeles, and the tallest in the United States west of the Mississippi River. Designed by Pei Cobb Freed & Partners (firm of renowned architect I. M. Pei), the building rises more than 1,000 feet above the city. *Larry Brownstein/California Stock Photo*

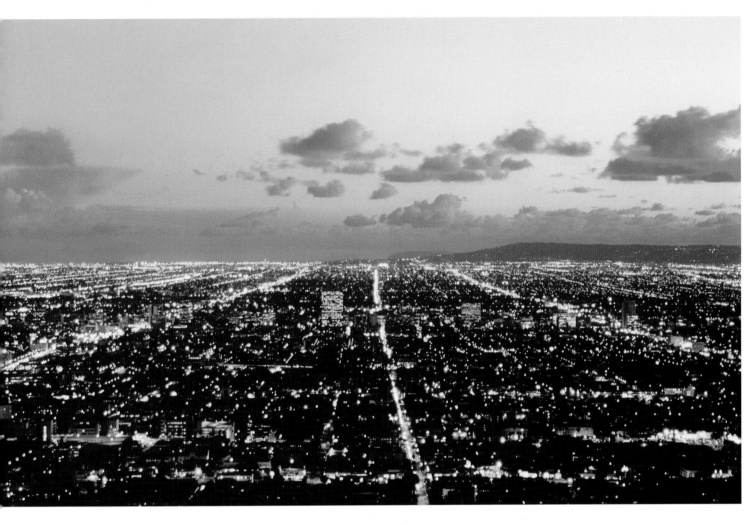

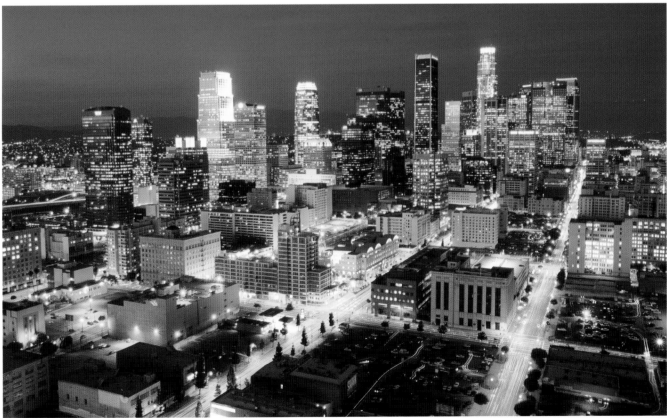

Downtown Los Angeles is bustling day and night, with restaurants, clubs, theaters, and many other activities for after the sun goes down. *Larry Brownstein/California Stock Photo*

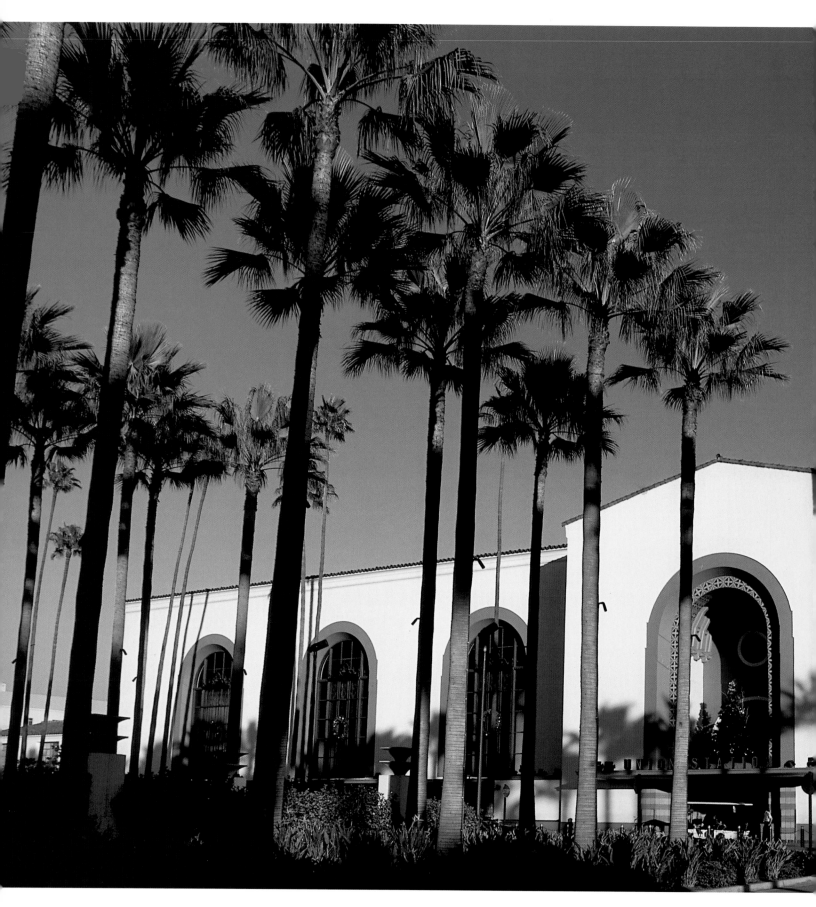

Union Passenger Terminal was built in 1939, just as the era of the grand railroad stations was coming to an end in America. Donald B. Parkinson's design for the building combines the simplicity of California's mission-style architecture with art deco details. *Peter Bennett/California Stock Photo*

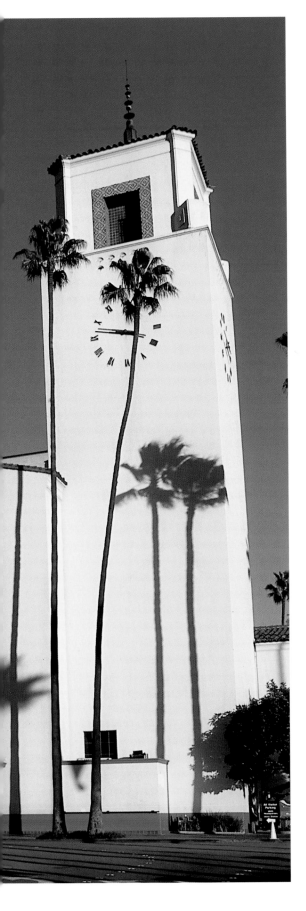

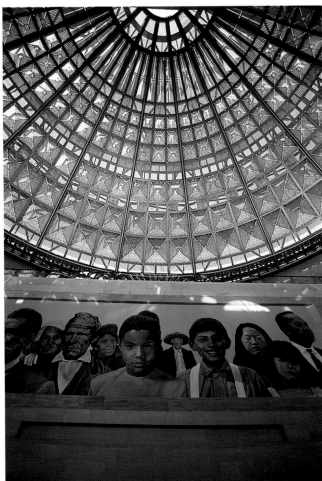

The interiors of Union Station feature a spectacular glass-dome ceiling and artworks depicting the cosmopolitan makeup of the city's population. This mural by Richard Wyatt is part of the public art project "City of Dreams/River of History." *Larry Brownstein/ California Stock Photo*

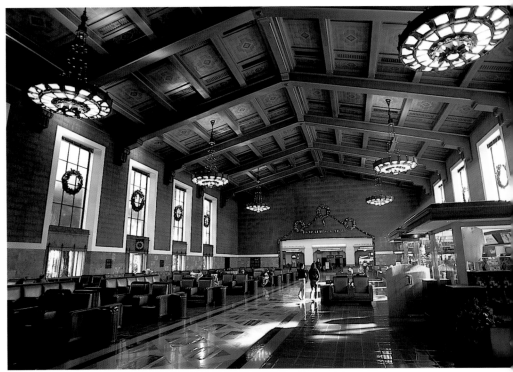

Today, Union Station bustles with Amtrak service to other cities as well as commuter lines such as Metrolink and Metrorail. Although you might expect noise to echo loudly within the towering ceilings and hard surfaces of the vast entrance area and waiting room, the walls are lined with sound-absorbing cork. *Peter Bennett/California Stock Photo*

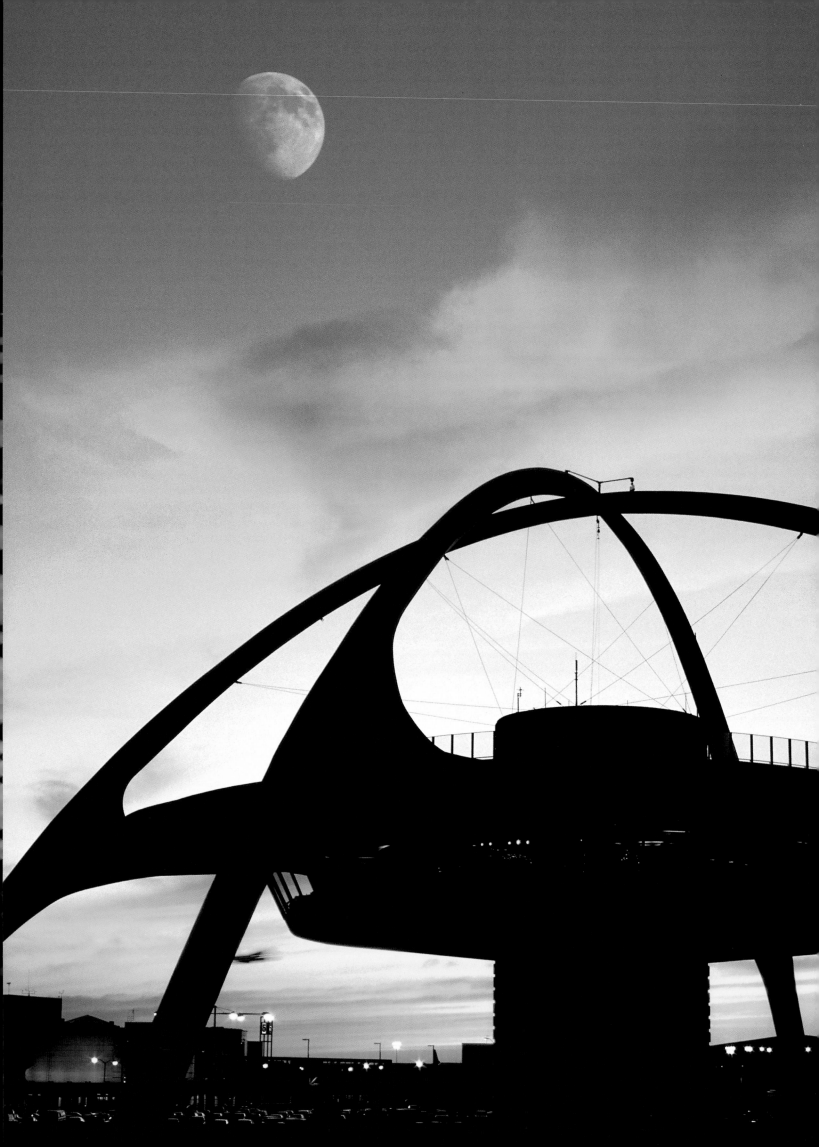

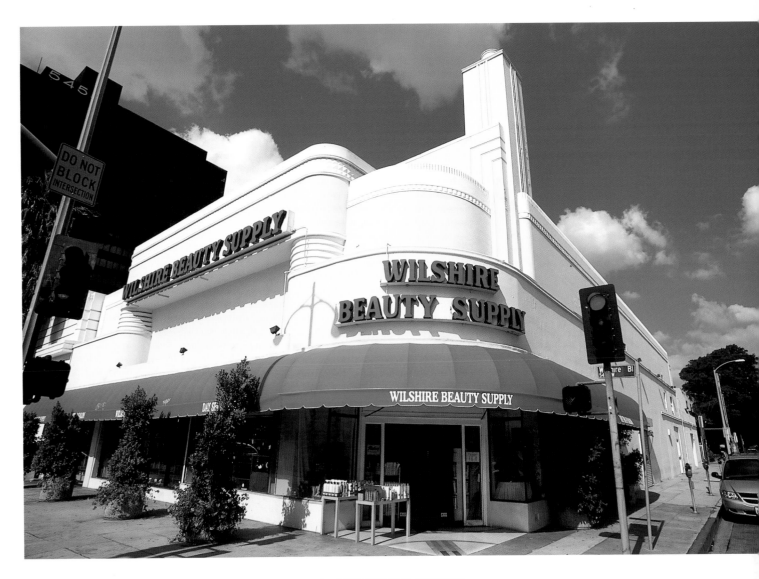

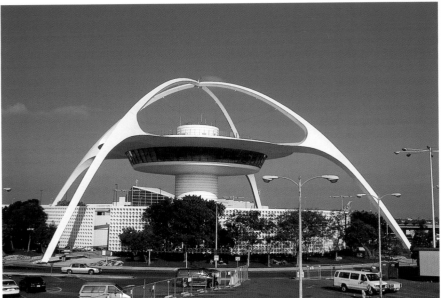

The Wilshire Beauty Supply building is a prime example of the art deco architecture that was in vogue during the 1920s, when Wilshire Boulevard was being developed to cater to motorists. The strip between La Brea and Fairfax Avenues came to be known as the Miracle Mile, because developer A. W. Ross created one of the era's most popular shopping districts out of nothing. *Peter Bennett/California Stock Photo*

The space-age building designed by William Pereira in 1962 has become synonymous with Los Angeles International Airport. The structure houses a restaurant. *Larry Brownstein/California Stock Photo (left); Mark Downey/ California Stock Photo (above)*

Above:

Icons of 1950s car culture remain throughout Los Angeles as a tribute to a bygone era. This Googie-style car wash adorns Pico Boulevard near West LA. *Larry Brownstein/California Stock Photo*

Facing page:

The Bob's Big Boy in Burbank, designed by architect Wayne McAllister, is the oldest Big Boy in existence, dating back to 1949. The restaurant's fiberglass mascot still stands, larger than life. *Peter Bennett/California Stock Photo*

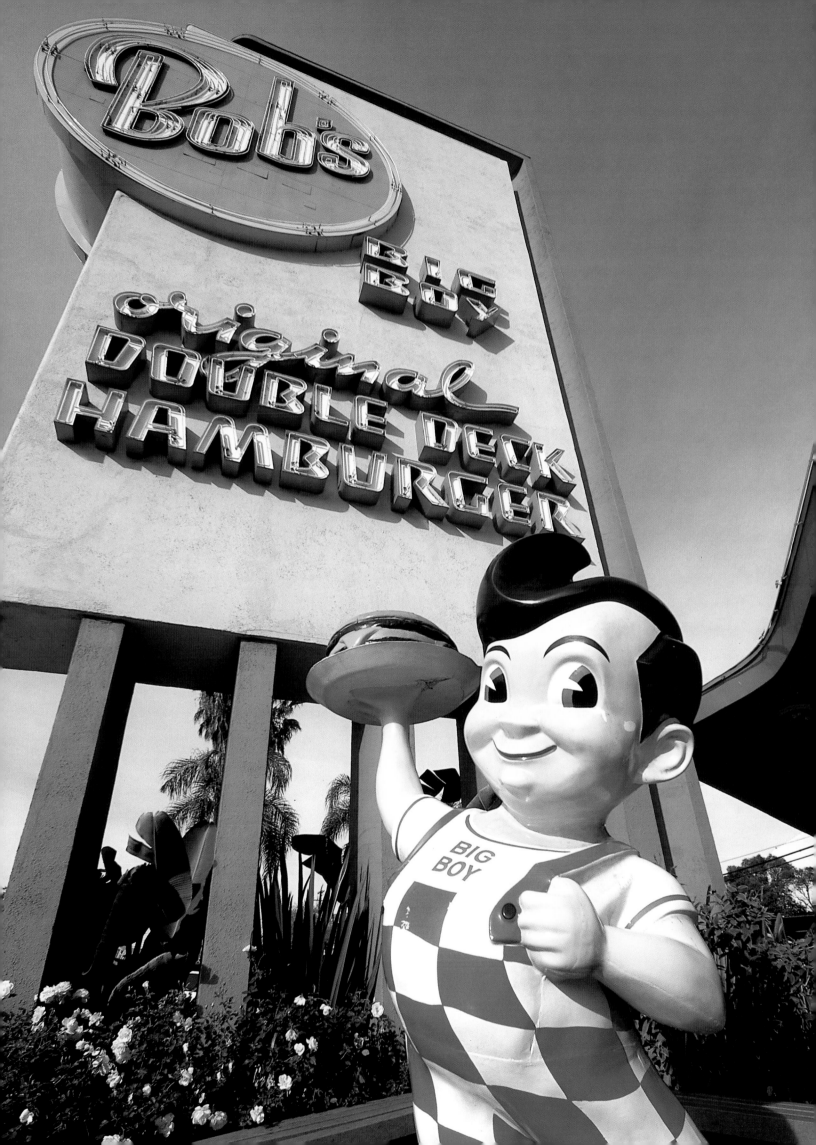

Mmm . . . donuts. The giant, twenty-two-foot-tall donut that tops this well-known Inglewood establishment attracts hungry tourists and locals eager to sample Randy's menu of tasty treats. *Larry Brownstein/ California Stock Photo*

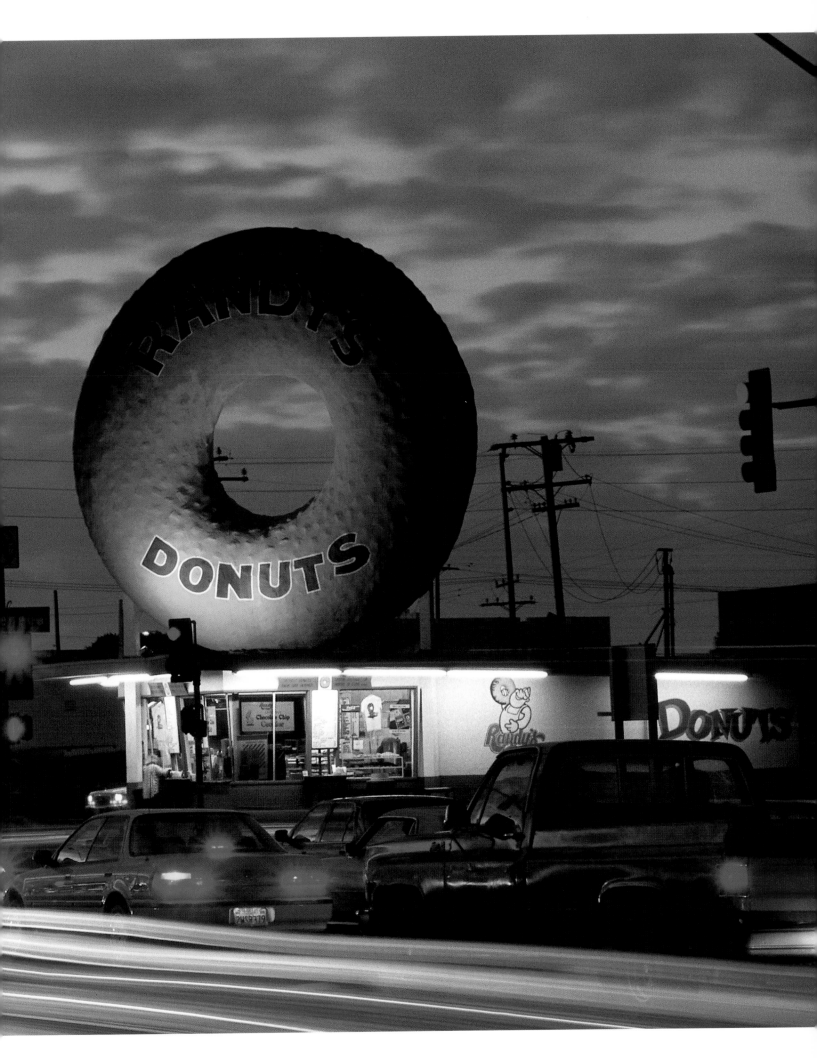

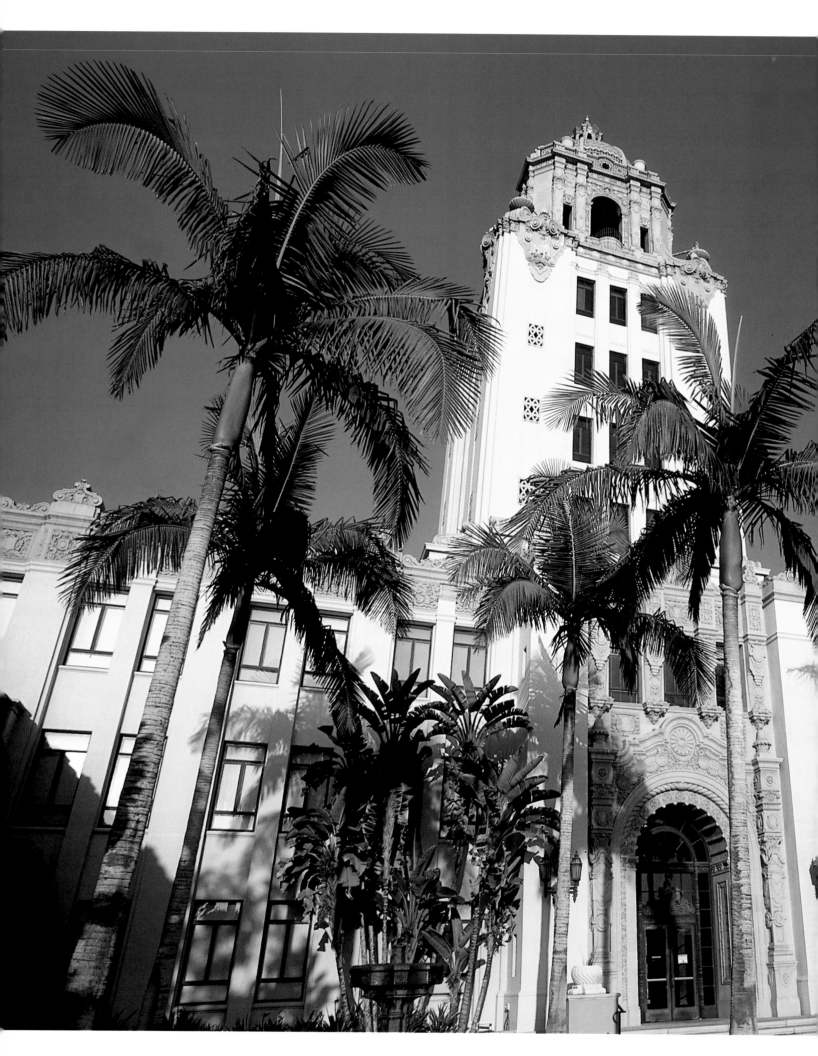

Designed by William Gage in the style of the Spanish Renaissance, the Beverly Hills City Hall has gracefully stood watch over the elegant town since 1932. *Peter Bennett/California Stock Photo*

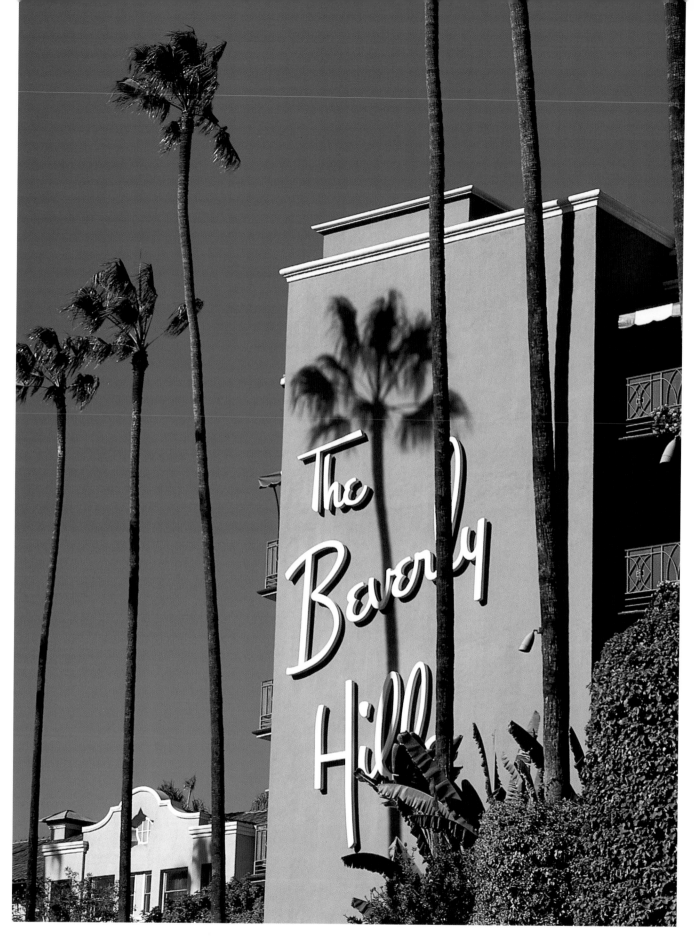

The Beverly Hills Hotel is a true icon of southern California. It opened in 1912 when most of the surrounding land consisted of bean fields. Before long, the hotel lobby was a watering hole for the likes of John Barrymore, Will Rogers, W. C. Fields, and other Hollywood stars making their home in this growing city. The hotel underwent extensive renovations in the 1950s and the early 1990s. This wing, with New Orleans–style balconies, was added during the 1950s remodel.
Peter Bennett/California Stock Photo

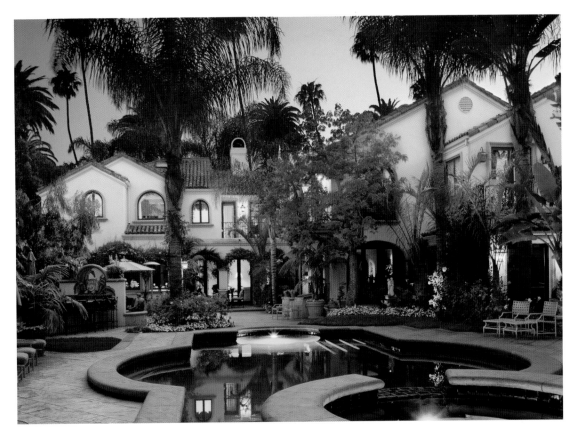

Some of the most stately homes in the country can be found right here in Beverly Hills, which has been a haven for movie stars since the 1920s. *Peter Bennett/California Stock Photo*

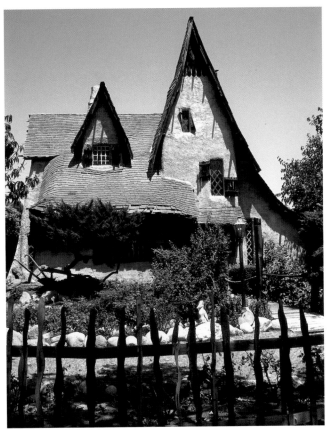

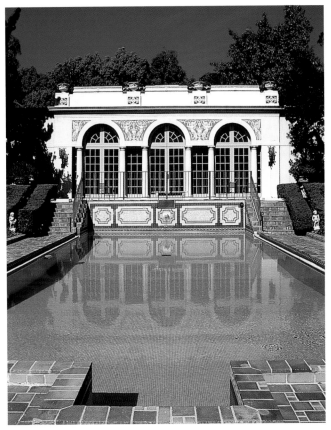

This fairy-tale-style cottage represents the more whimsical side of Beverly Hills's eclectic residences. Known as the "Witch's House," it was originally built for a movie set in Culver City. *Richard Carroll/California Stock Photo*

Built in 1911, the Virginia Robinson estate was one of the first mansions in Beverly Hills. Its extensive, lush tropical gardens as well as the house are open to the public—although you probably shouldn't take a dip in the Mediterranean-style pool. *Larry Brownstein/California Stock Photo*

Right:

Outside the Beverly Wilshire, a chauffeur waits alongside a Rolls Royce, ready to escort his passengers to their next destination in style. *Richard Carroll/California Stock Photo*

Below:

A romantically lit lobby, defined by opulent columns and a marble tiled floor, welcomes visitors to the Beverly Wilshire Hotel. The hotel has been a favorite among the Hollywood set since 1928. *Larry Brownstein/California Stock Photo*

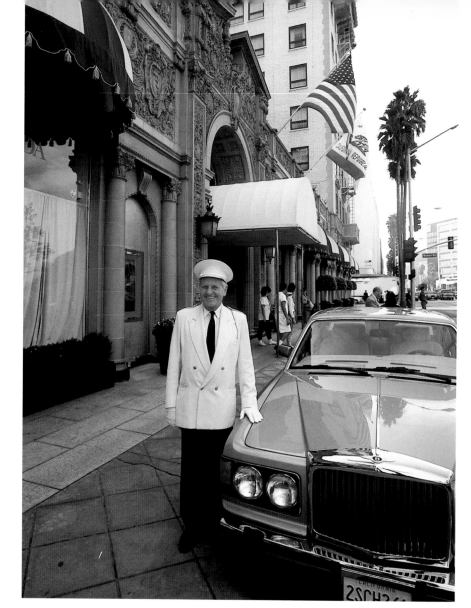

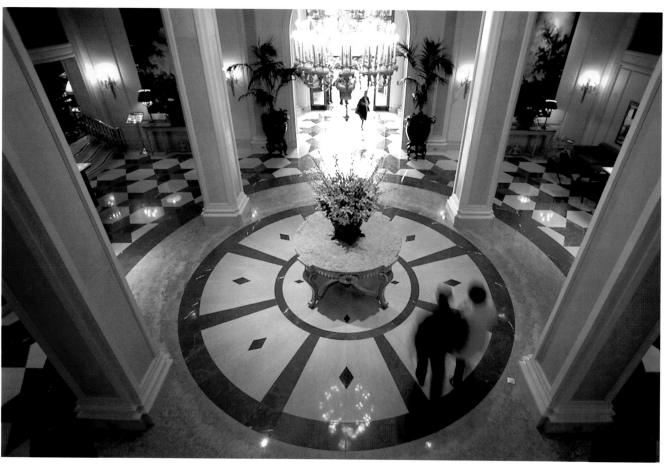

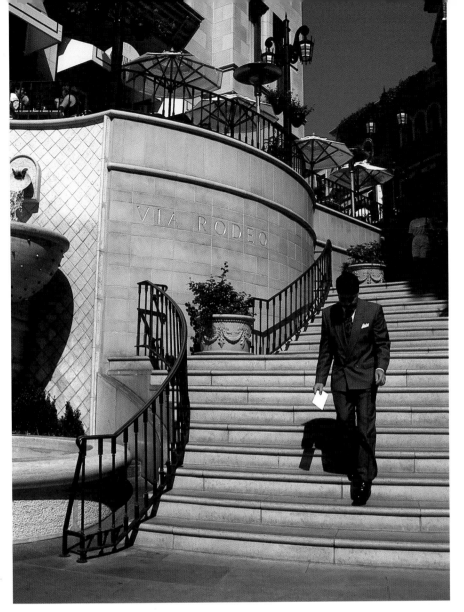

Left:
An elegant staircase along Rodeo Drive, the Fifth Avenue of Beverly Hills, leads shoppers to an outdoor café above street level. *Richard Carroll/California Stock Photo*

Below:
Artfully arranged antiques fill the storefront window of one of Rodeo Drive's famously chic boutiques. *Larry Brownstein/California Stock Photo*

On the overleaf:
Via Rodeo, located right off of swanky Rodeo Drive, offers high-class shopping—for those who can afford it. Rodeo Drive is home to such exquisite shops as Gucci, Armani, Ralph Lauren, and Cartier. *Peter Bennett/California Stock Photo*

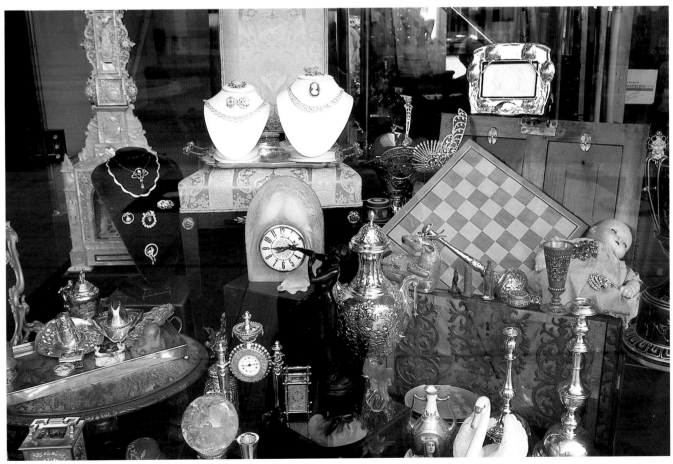

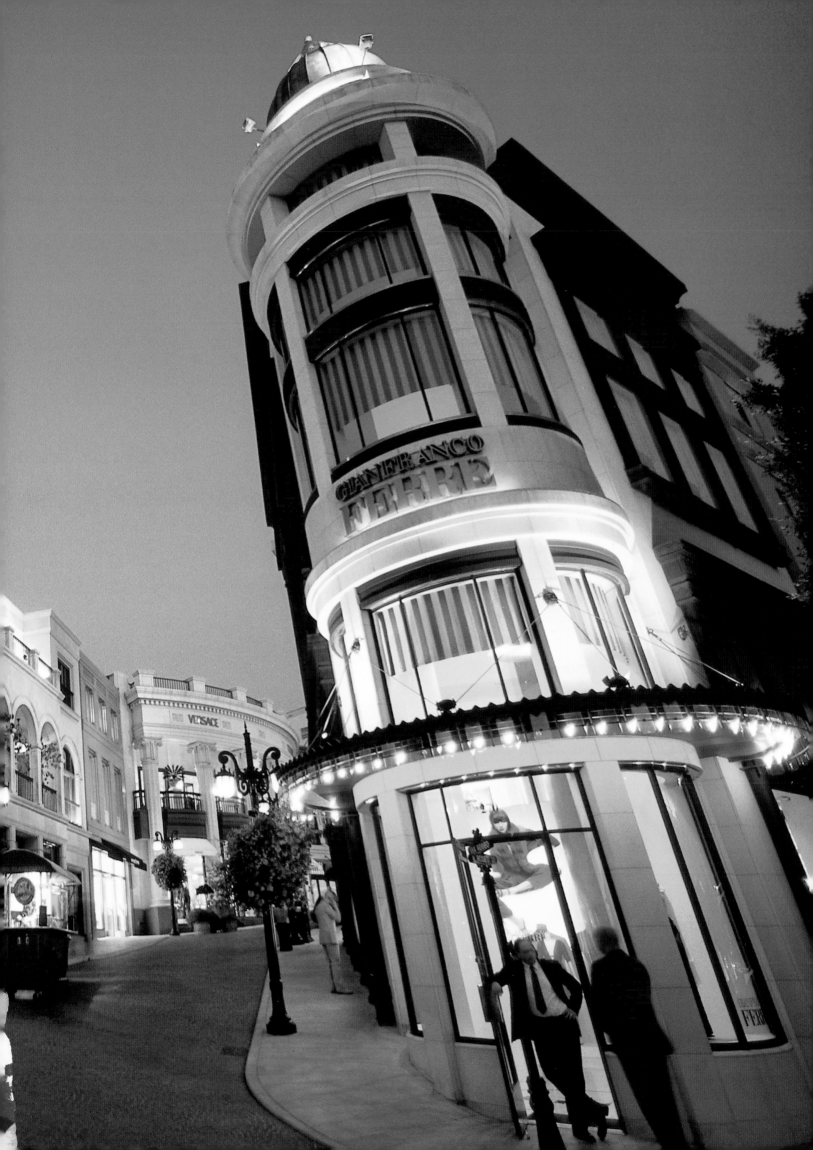

Frederick Mellinger opened the original Frederick's of Hollywood on Hollywood Boulevard in 1947. In addition to creating the first push-up bra, which he aptly named the Rising Star, Mellinger dedicated a section of his store to the display of lingerie worn by the stars. Today, visitors to the Frederick's of Hollywood Lingerie Museum can sneak a peak at everything from Madonna's pointed-breast corset to Tony Curtis's bra from the film *Some Like It Hot. Richard Carroll/ California Stock Photo*

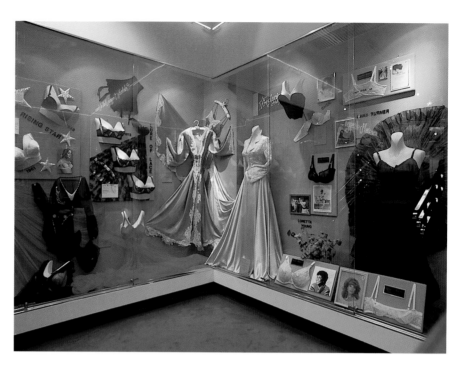

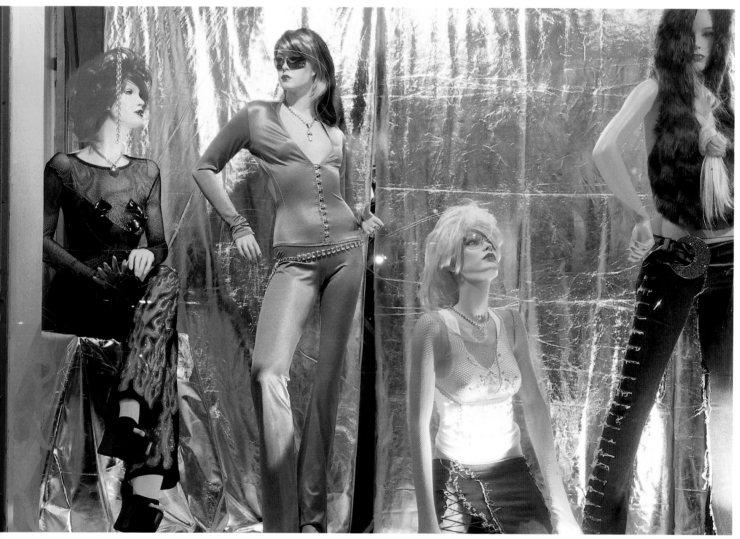

Mannequins with attitude brighten a shop window along Melrose Avenue. This popular shopping district is known for its funky vintage clothing shops, eccentric art galleries, and fine eateries. *Larry Brownstein/California Stock Photo*

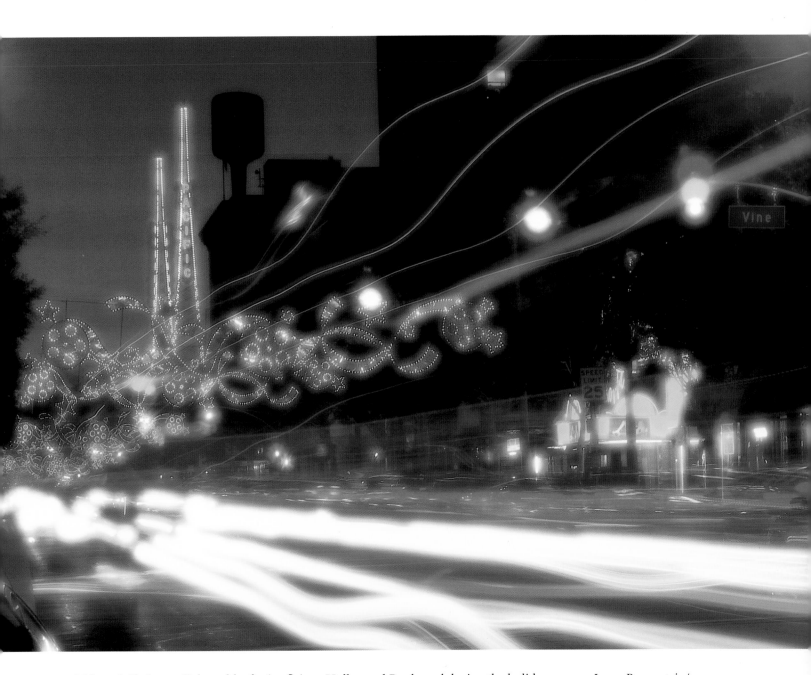

A blur of Christmas lights add a festive flair to Hollywood Boulevard during the holiday season. *Larry Brownstein/ California Stock Photo*

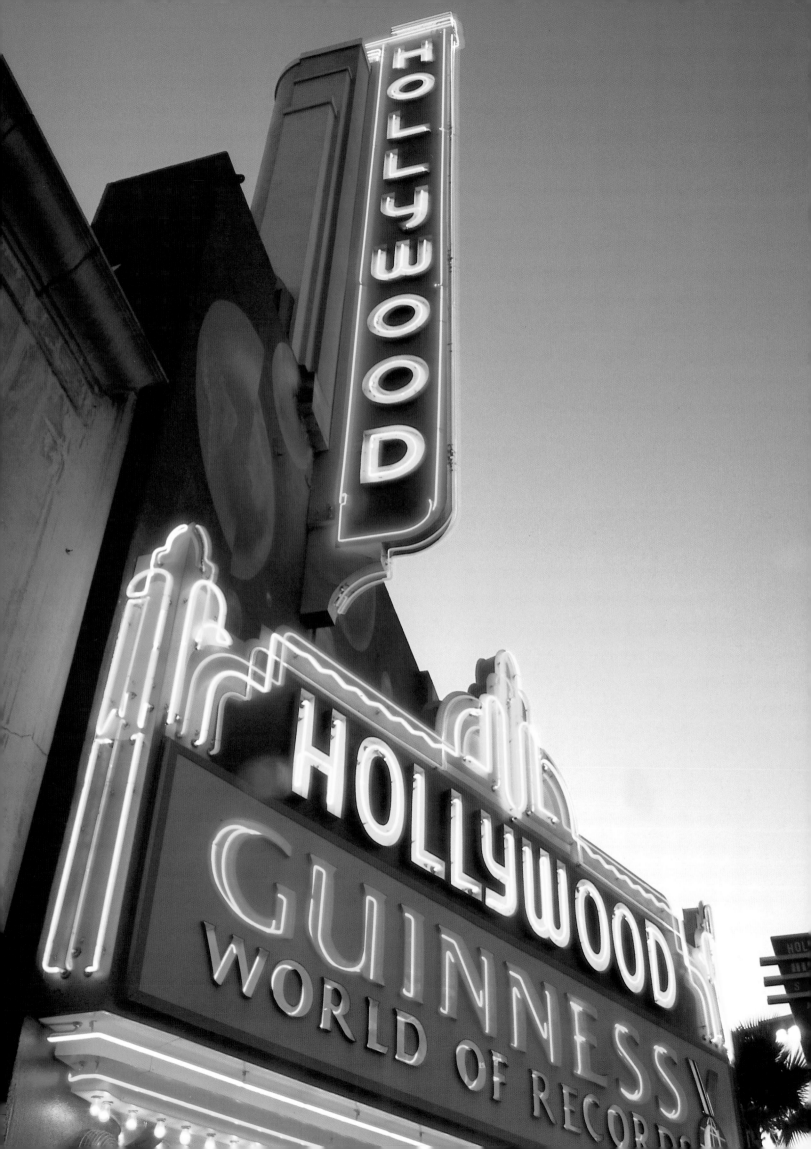

Facing page:

The colorful marquee for the Hollywood Guinness World of Records Museum draws in tourists from Hollywood Boulevard to view exhibits celebrating the world's largest this and smallest that. The museum is housed in the historic Hollywood Theatre, built in 1938. *Larry Brownstein/California Stock Photo*

Left:

Ship-shaped Crossroads of the World, the world's first open-air shopping mall, has been docked along Sunset Boulevard since 1936. *Peter Bennett/California Stock Photo*

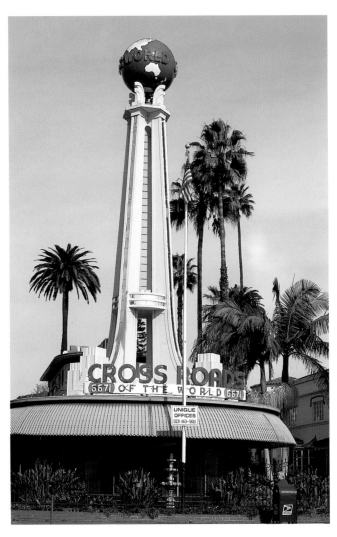

Below:

Showy billboards flank the Sunset Strip, the famous mile-and-a-half span of Sunset Boulevard between Crescent Heights Boulevard and Doheny Drive. The strip is best known for its nightclubs and boutiques. Sunset Boulevard, which runs from downtown LA to the Pacific Ocean near Malibu, was the main route between the studios of Hollywood and the posh residential areas of Beverly Hills and Bel-Air. *Peter Bennett/California Stock Photo*

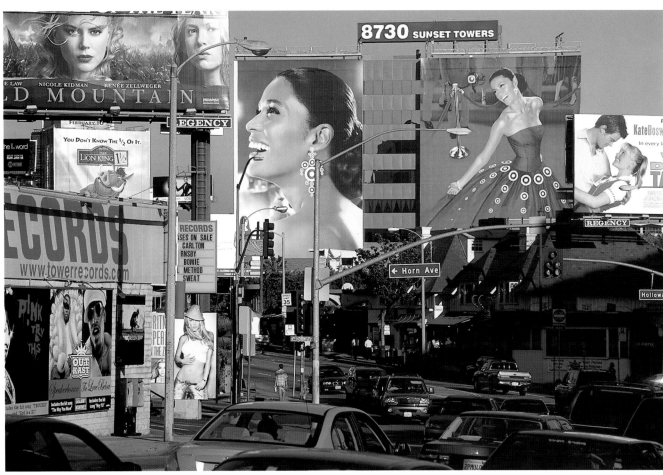

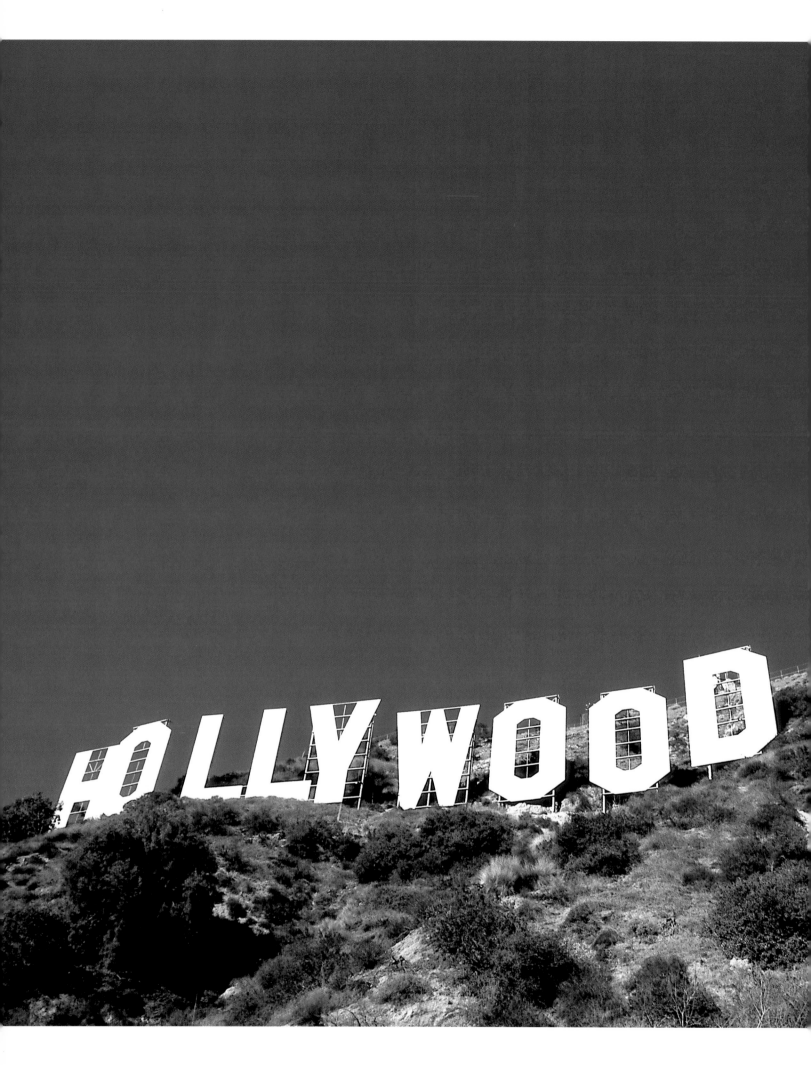

Fifty feet high and four hundred and fifty feet long, the Hollywood billboard has stood atop Mount Lee in the Hollywood Hills since 1923. The famous sign was originally built to advertise Hollywoodland, a subdivision created by developer Harry Chandler, but the Hollywood Chamber of Commerce removed the final four letters in 1945. *Peter Bennett/California Stock Photo*

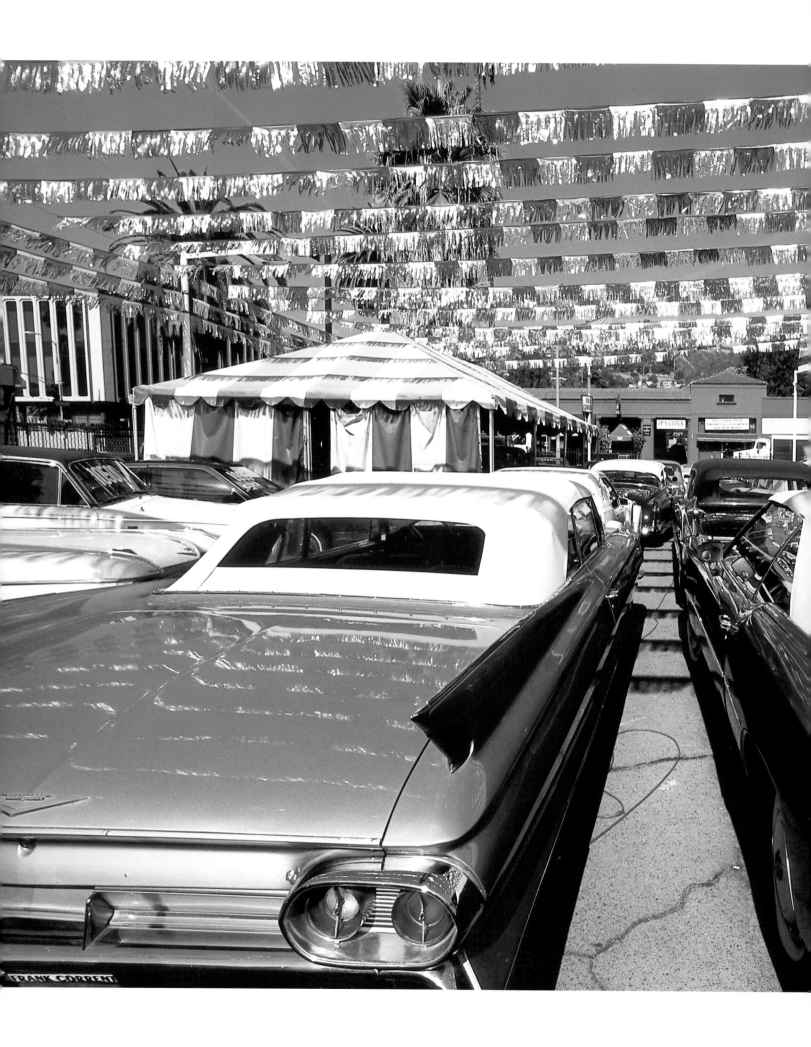

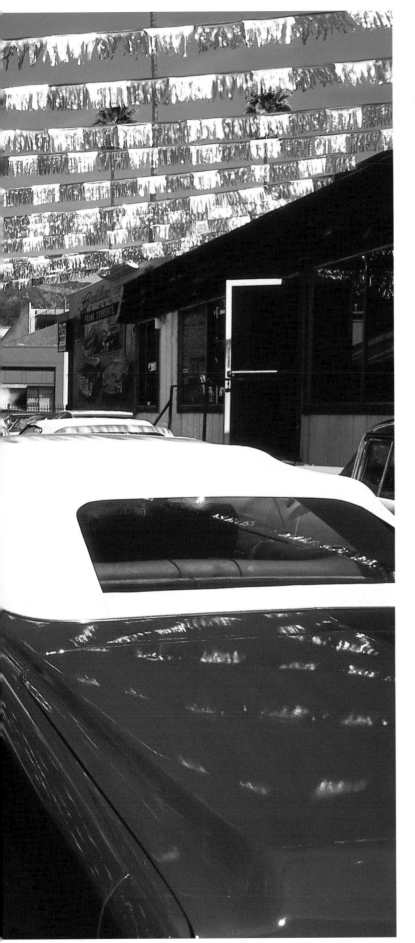

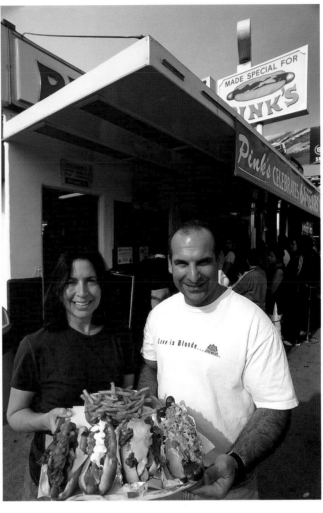

Above:

The late Paul Pink started selling hot dogs for ten cents a piece from a humble cart along La Brea Avenue more than sixty years ago. Today, Pink's Hot Dogs is a Hollywood institution. Aficionados line up to indulge in the tasty dogs slathered with chili, onions, mustard—and so much more. *Peter Bennett/California Stock Photo*

Left:

More than one hundred vintage Caddies fill Frank Corrente's Cadillac Corner in Hollywood, California. *Larry Brownstein/California Stock Photo*

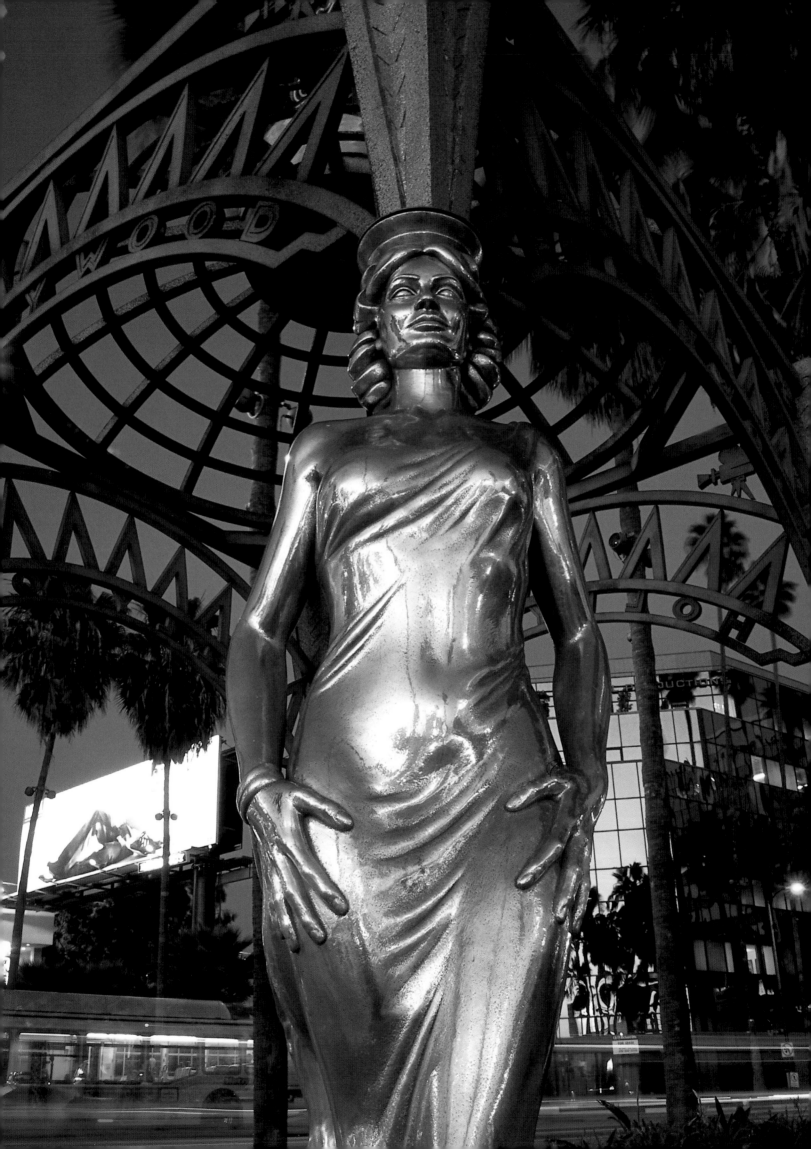

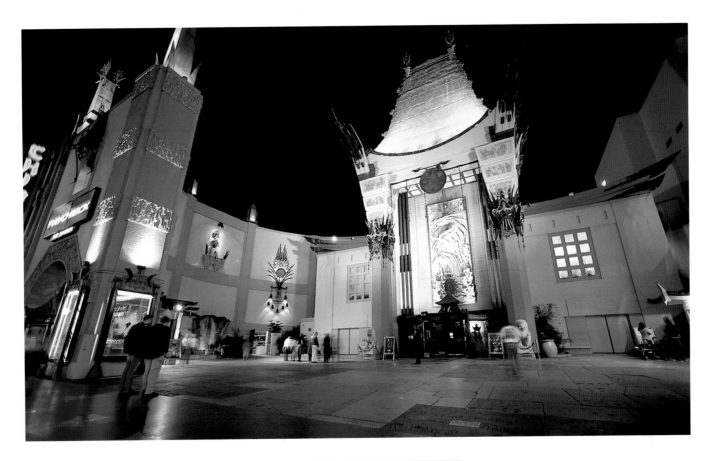

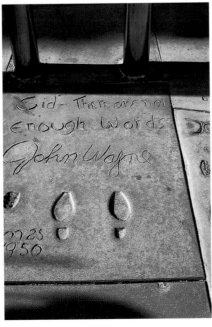

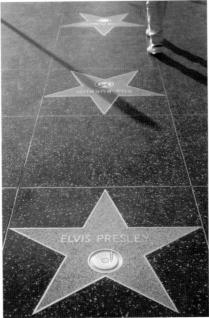

The pagoda-style architecture of Grauman's Chinese Theatre is graced by a large dragon snaking across the front, while two stone lion-dogs guard the entrance. This Hollywood landmark opened in 1927 with the first screening of Cecil B. DeMille's *King of Kings*, and the vintage venue continues to host major film premieres. *Peter Bennett/California Stock Photo*

The Hollywood Starlet Statue is a monument to the city's glamorous film industry. It stands in all its shimmering silver glory on the corner of La Brea Avenue and Hollywood Boulevard. *Larry Brownstein/California Stock Photo*

A main attraction at Grauman's Theatre are the hand and foot prints that stars have pressed into the pavement outside since 1927. Among the more than 170 celebrities so honored, film tough-guy John Wayne left an imprint of his fist along with his feet in 1950. *Richard Carroll/California Stock Photo*

Brass and terrazzo star plaques, each emblazoned with the name of a movie star, comedian, or musician, make up Hollywood's Walk of Fame. First dreamed up in 1958 by businessman Harry Sugarman, the Walk now extends more than thirty-five blocks through Hollywood, with a new star added every month. *Jeffrey Greenberg/California Stock Photo*

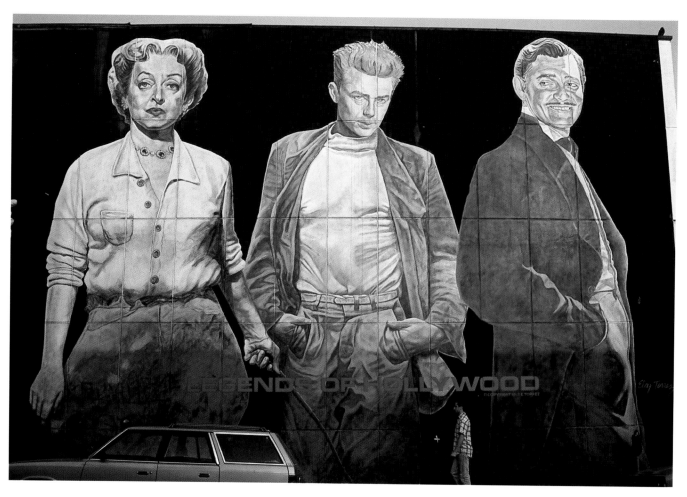

Above:

In Eloy Torrez's 1983 mural, *Legends of Hollywood*, likenesses of Marilyn Monroe, Humphrey Bogart, Fred Astaire, Bette Davis, James Dean, and Clark Gable loomed large on a building off of Hollywood Boulevard. Although the mural was destroyed in the major 1994 earthquake, the Hollywood Chamber of Commerce has plans to restore the mural at a new location. *Richard Carroll/ California Stock Photo*

Right:

Hollywood Forever Cemetery is one of six cemeteries in Los Angeles where movie buffs can visit the gravesites of their favorite stars. Among the Hollywood greats buried here are Rudolph Valentino, Cecil B. DeMille, and John Huston. *Peter Bennett/California Stock Photo*

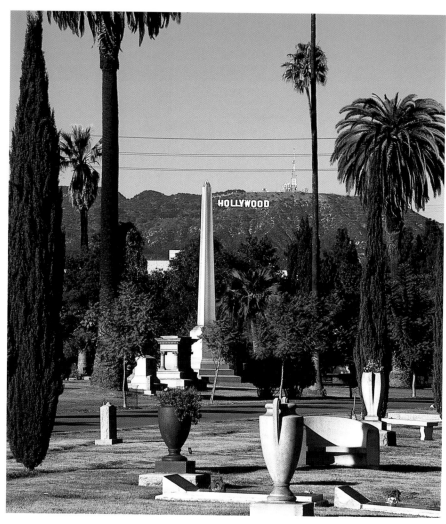

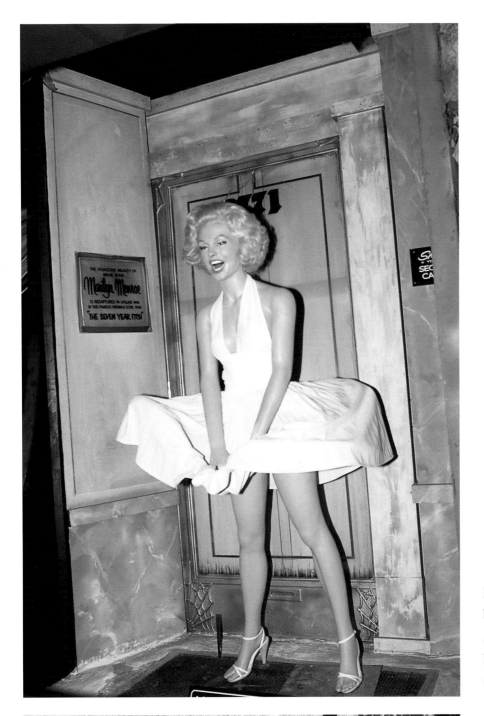

Marilyn Monroe's famous skirt-blowing scene from *The Seven Year Itch* is forever captured in wax at the Hollywood Wax Museum. *Richard Carroll/California Stock Photo*

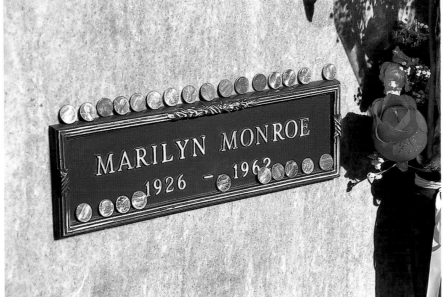

Marilyn Monroe's final resting place is in Westwood Village Memorial Park, where she shares real estate with the likes of Truman Capote, Dean Martin, Roy Orbison, Natalie Wood, Frank Zappa, Jack Lemmon, and Walter Matthau. *Peter Bennett/ California Stock Photo*

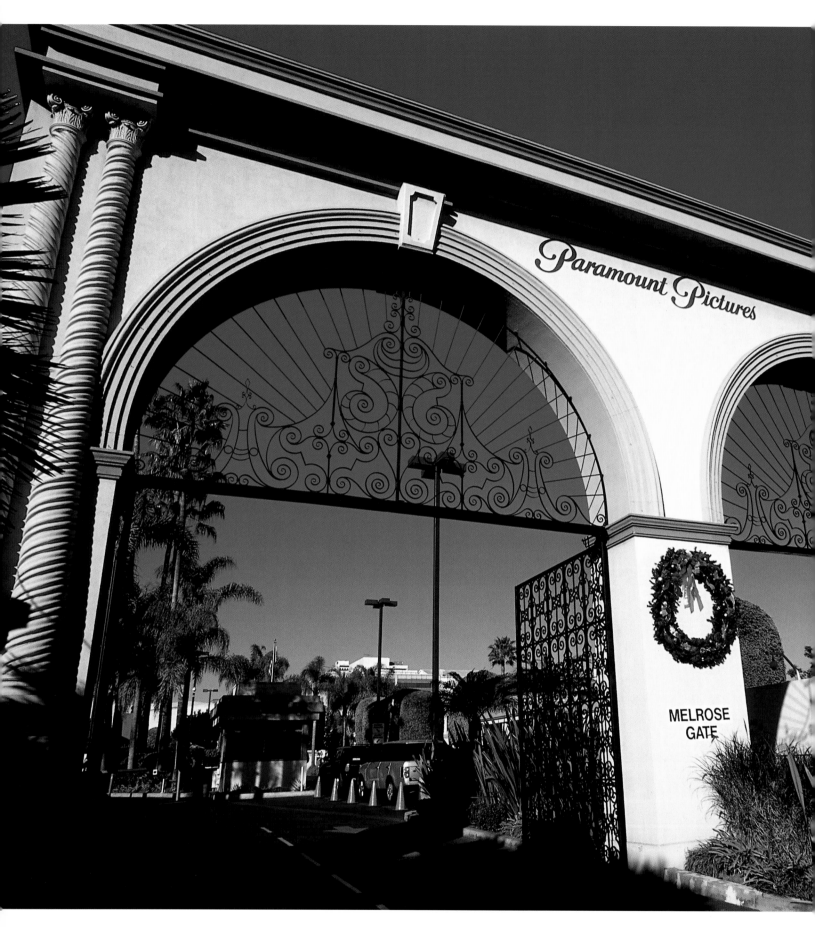

Paramount Pictures Corporation is the only one of the five major movie studios still located in Hollywood. Theater owner William Wadsworth Hodkinson established Paramount in 1914, and the company went on to produce such classic films as *A Farewell to Arms, Roman Holiday, The Godfather,* and *Raiders of the Lost Ark. Peter Bennett/California Stock Photo*

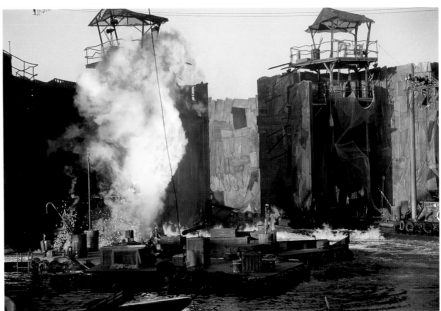

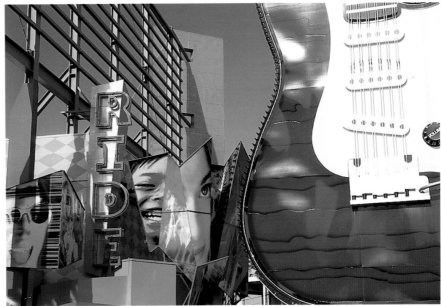

Top:

The set of the 1995 film *Waterworld* erupts into flames on the grounds of Universal Studios. Universal Pictures, established in 1909 by Carl Laemmle, has produced several of the highest grossing films of all time, including *Jurassic Park, E.T.: The Extra Terrestrial,* and other Steven Spielberg films of the 1970s, '80s, and '90s. *Mark E. Gibson/California Stock Photo*

Bottom:

In addition to the lavish Universal Studios theme park, Universal City is home to City Walk, a huge shopping and entertainment complex, filled with delights for all the senses. *Larry Brownstein/California Stock Photo*

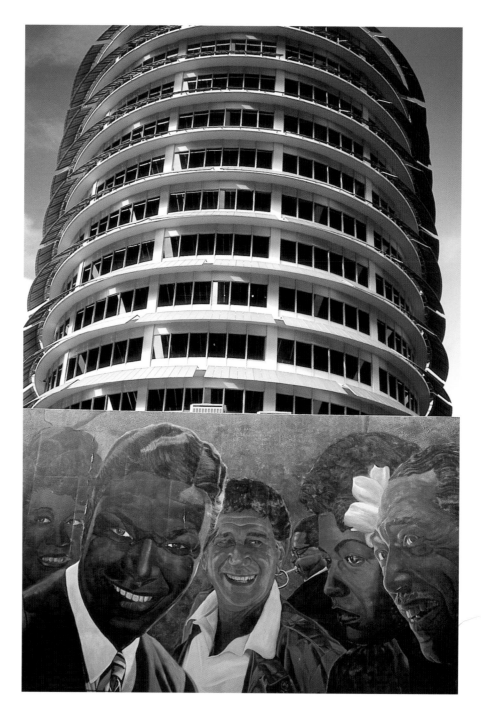

Top right:

Resembling a stack of 45rpm records on a turntable, the Capitol Records Building has stood near the corner of Hollywood and Vine since 1954. Two murals decorate the base of the twelve-story office tower. *Hollywood Jazz* by Richard Wyatt features jazz legends such as Duke Ellington, Nat King Cole, Miles Davis, and Billie Holiday. *Larry Brownstein/ California Stock Photo*

Bottom right:

The Roosevelt Hotel Hollywood was known as the "Home of the Stars" in its heyday, when it was a popular stop for many prominent actors. Built in 1927 with financing from such Hollywood luminaries as Mary Pickford, Douglas Fairbanks, and Louis B. Mayer, the Roosevelt was the site of the very first Academy Awards presentation in 1929. *Richard Carroll/ California Stock Photo*

Facing page:

The majestic Fox Westwood Village Theater (now called Mann's Village Theater) beckons moviegoers from miles away. Built in the Westwood section of LA in 1931, the theater has been the site of many major pre-mieres in its seven decades. *Peter Bennett/California Stock Photo*

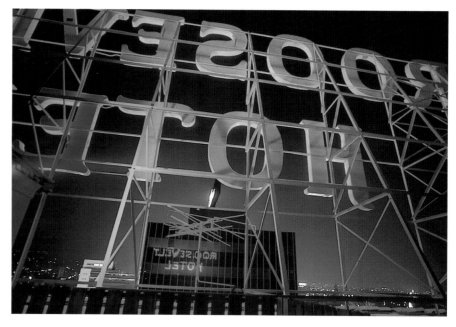

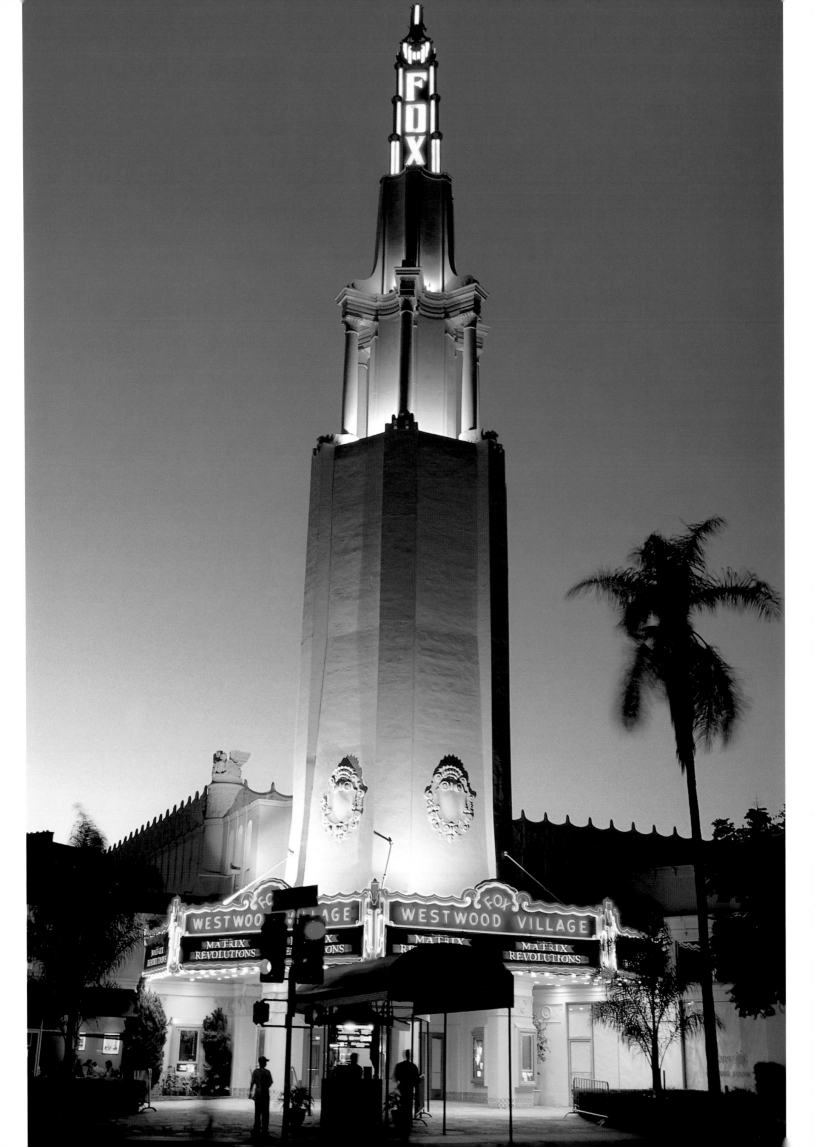

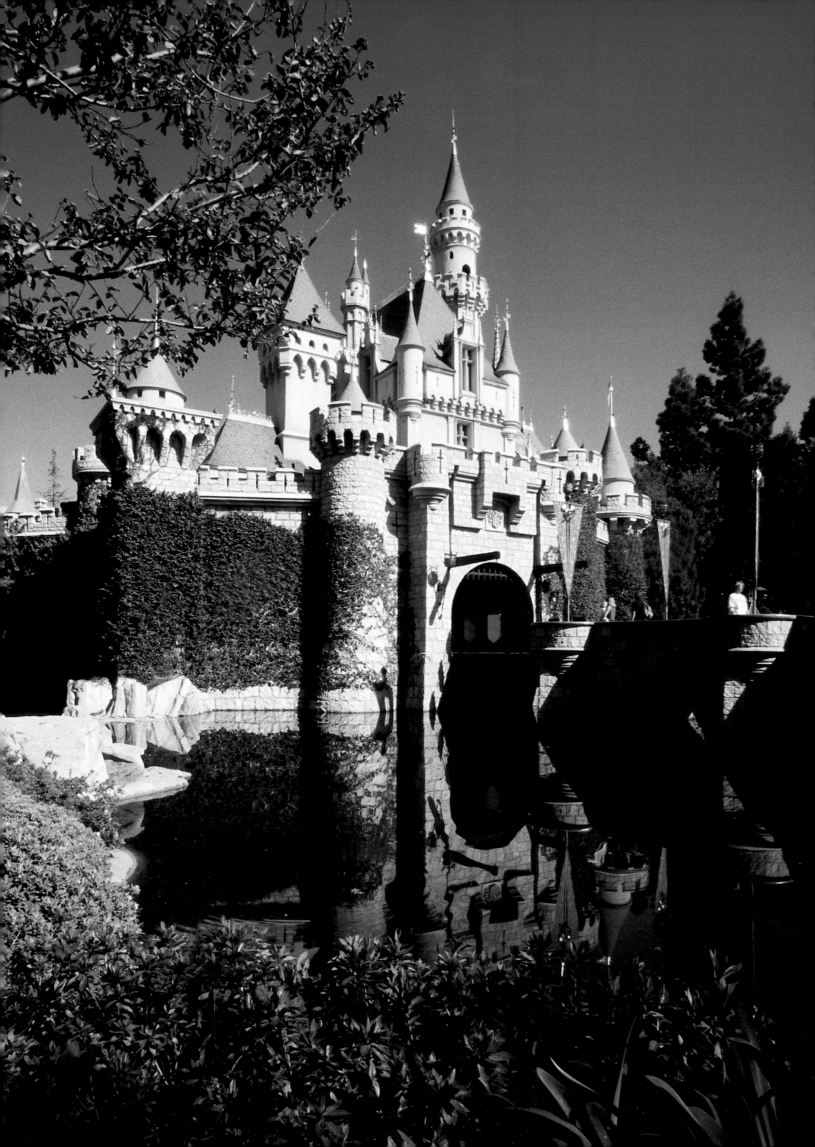

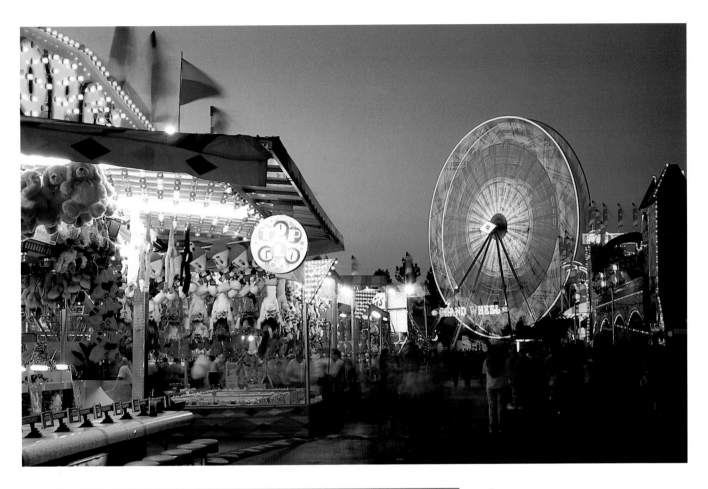

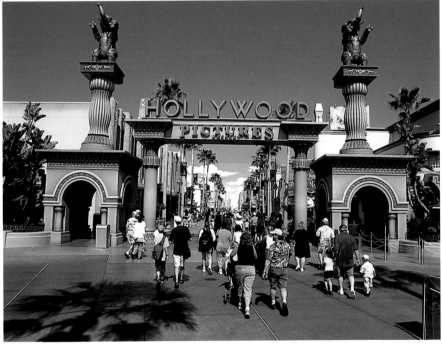

Above:
The Disneyland Resort underwent a major expansion in 2001, including the addition of Disney's California Adventure theme park. At the Hollywood Pictures Backlot, visitors can wander along a replica Hollywood Boulevard and explore the many exhibits in the Disney Animation building. *Larry Brownstein/ California Stock Photo. Used by permission from Disney Enterprises, Inc.*

Above:
Every September, the Pomona sky lights up with the whirling Ferris wheel and pulsing midway of the Los Angeles County Fair. It is the largest county fair in the United States, drawing millions of visitors and top entertainment acts. *Larry Brownstein/ California Stock Photo*

Facing page:
Sleeping Beauty Castle welcomes visitors to Fantasyland in the world-renowned Disneyland Park in Anaheim. Many of the rides and attractions in Fantasyland are inspired by classic Disney characters like Dumbo, Pinocchio, Snow White, and others. First opened in 1955, Disneyland remains one of the most visited theme parks in the world. *Richard Carroll/California Stock Photo. Used by permission from Disney Enterprises, Inc.*

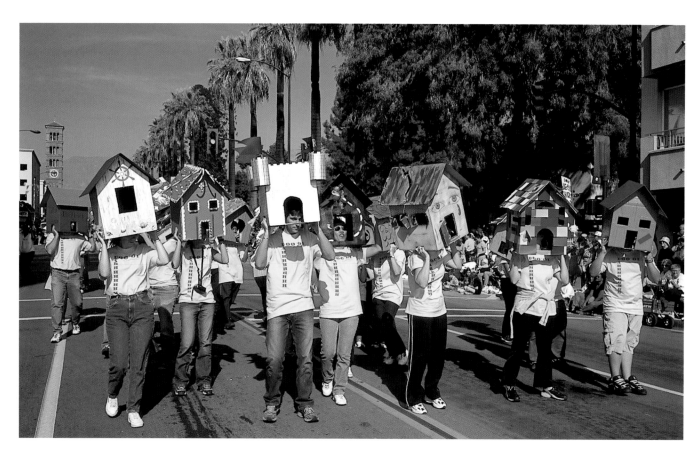

Fun and mayhem rule at Pasadena's annual Doo-Dah Parade. Originating as a parody of the highly regimented Rose Bowl Parade, the Doo-Dah attracts thousands of Californians dressed in outrageous costumes or marching to promote political causes. It is held every November on the Sunday before Thanksgiving. *Larry Brownstein/California Stock Photo*

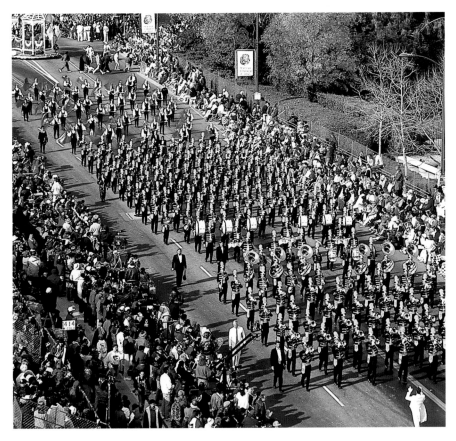

Left:
The Tournament of Roses Parade draws marching bands and participants to Pasadena from all around the country every New Year's Day. A tradition since 1890, the parade route runs five and a half miles and lasts more than two hours. It is televised worldwide. *Larry Brownstein/California Stock Photo*

Creativity abounds as Halloween revelers crowd Santa Monica Boulevard in West Hollywood to show off their costumes. The West Hollywood Costume Carnival is the largest Halloween celebration in North America, with as many as 400,000 people—and pets—celebrating in the streets. *Larry Brownstein/California Stock Photo*

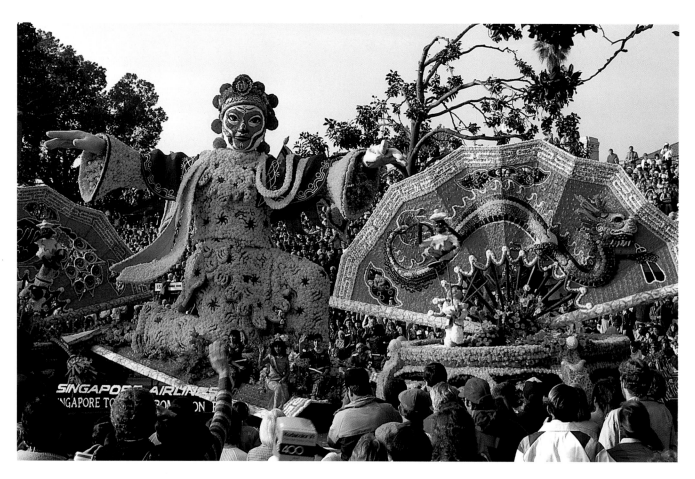

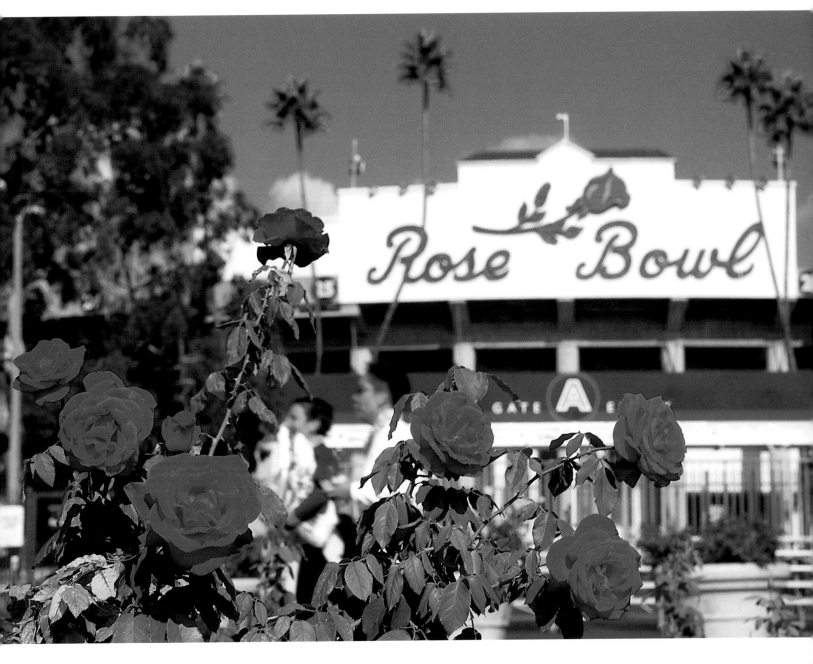

Above:

Rose Bowl Stadium in Pasadena has been the site of the annual showdown between the best of the Pacific-10 Conference and the Big Ten Conference since 1922. The "granddaddy of them all," the Rose Bowl is the oldest college football bowl game in the country. The stadium, which can accommodate more than 90,000 fans, is also the regular home of the UCLA football team, and it has hosted five NFL Super Bowls. *Peter Bennett/California Stock Photo*

Facing page:

Elaborate floats, decorated with fragrant flower blossoms, are the belles of the Tournament of Roses Parade. According to the rules of the parade, every inch of the float must be covered with flowers or other natural material such as leaves or bark. Nowadays, most of the floats are built by professionals, and some take as long as a year to construct. *Richard Carroll/ California Stock Photo (top); Larry Brownstein/California Stock Photo (bottom left and bottom right)*

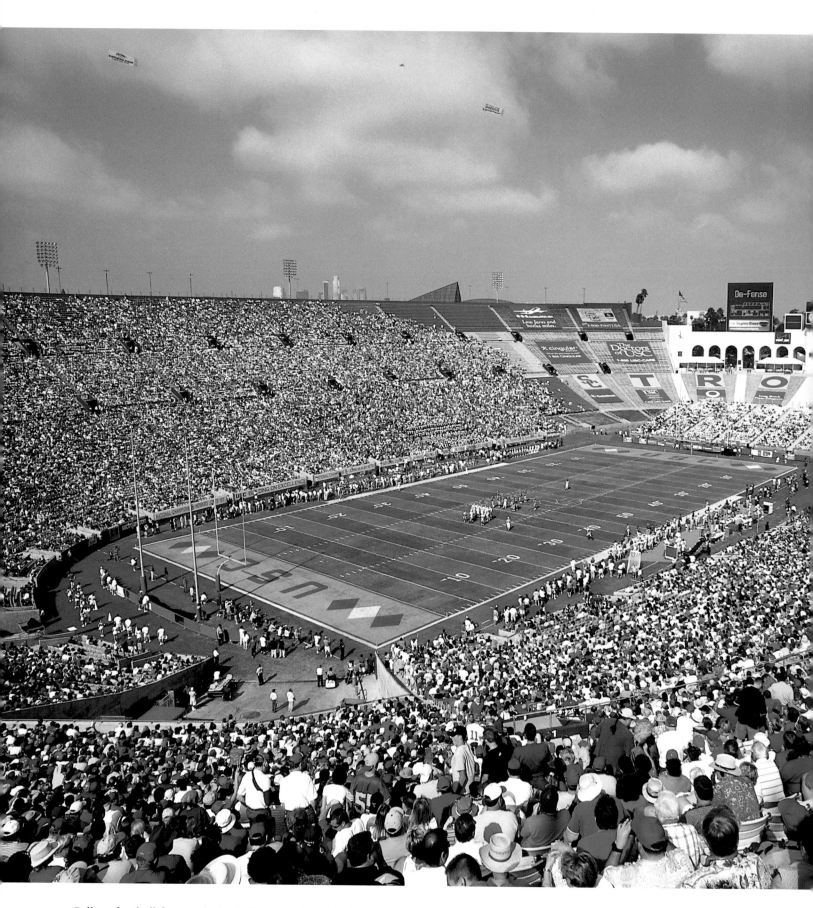

College football fans pack the Coliseum in Los Angeles to watch the University of Southern California Trojans battle their rivals. USC has sent many players to the top level of professional football in the NFL. *Peter Bennett/California Stock Photo*

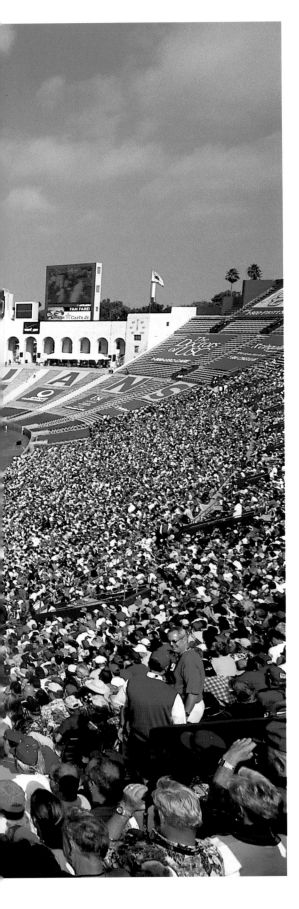

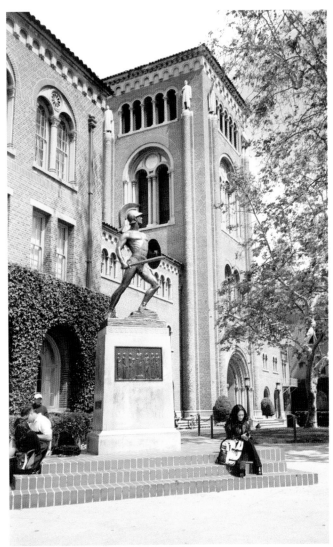

A statue of Tommy Trojan stands tall on the University of Southern California campus in Los Angeles. First established in 1880 with 53 students and 10 teachers, today some 31,000 students attend this institution. *Peter Bennett/ California Stock Photo*

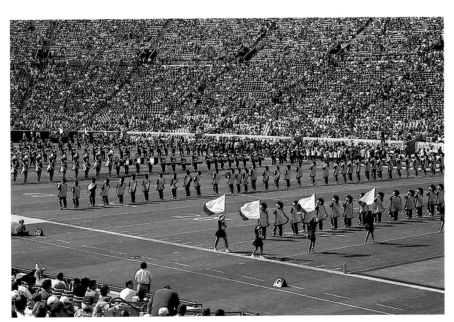

No college football game would be complete without a halftime show featuring the school's marching band. *Peter Bennett/California Stock Photo*

Right:

The University of California–Los Angeles began as the State Normal school in 1880. In 1919, it became the southern branch of the state university, and it moved to its current location in Westwood ten years later. The well-groomed campus offers many scenic spots for quiet study, including this fountain near Royce Hall. *Peter Bennett/California Stock Photo*

Below:

Trees shade Bruin Walk on the UCLA campus, located in Westwood Village. The University of California–Los Angeles is the largest university in California, with an enrollment of nearly 37,000 undergraduate and graduate students. *Peter Bennett/California Stock Photo*

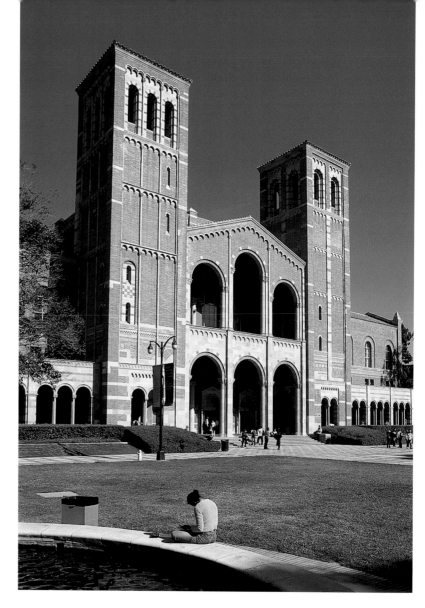

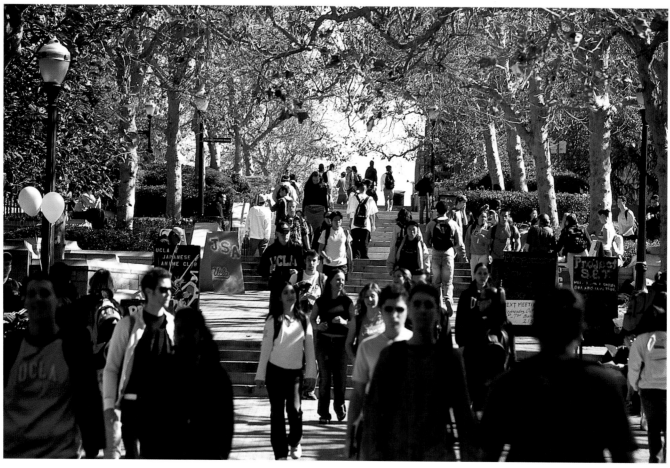

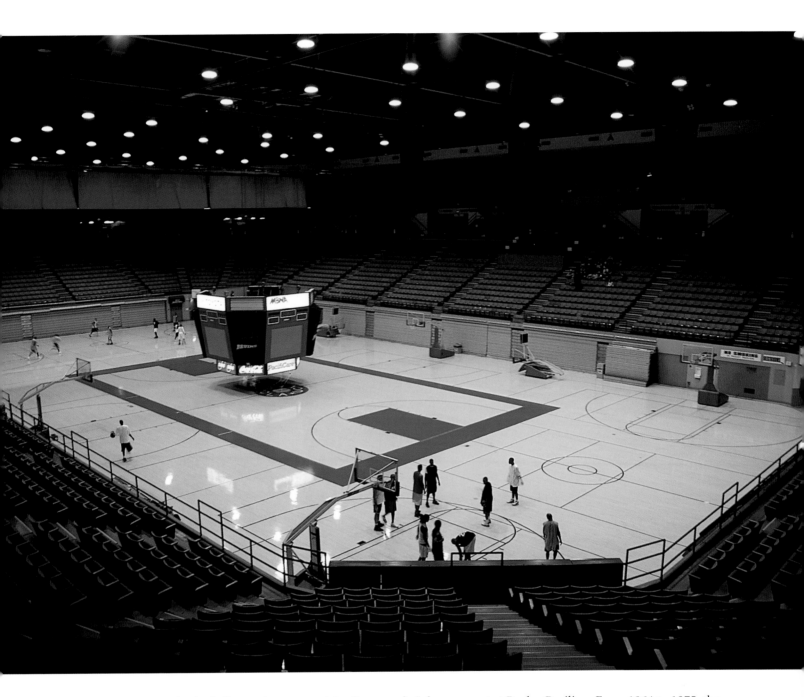

The UCLA Bruins basketball team is a competitive force on their home court at Pauley Pavilion. From 1964 to 1975, the team won a record ten national championships under the legendary coach John Wooden. The school won another NCAA title in 1995. *Peter Bennett/California Stock Photo*

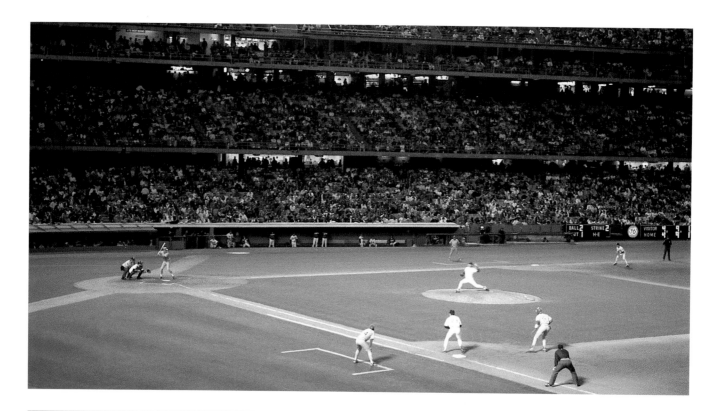

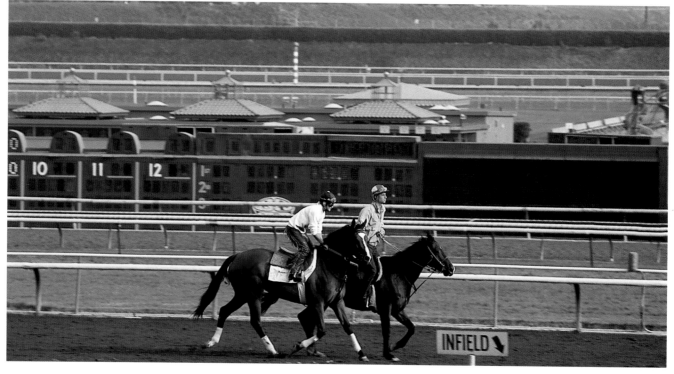

Top:

The Los Angeles Dodgers often play to a full house at Dodger Stadium. In 1978, they became the first baseball team to attract more than three million fans in a season, a feat they have repeated many times since. The venue, which seats 56,000, was state of the art when it opened in 1962 at Chavez Ravine. *Richard Carroll/California Stock Photo*

Bottom:

For an exciting day at the track, horse-racing enthusiasts get their fix at the Santa Anita Race Track in Arcadia. Racing season runs from December 26 through April and again from October through November. The track, which opened in 1934, was the site of the final victory in the career of racehorse Seabiscuit, in the 1940 Santa Anita Handicap. *Richard Carroll/California Stock Photo*

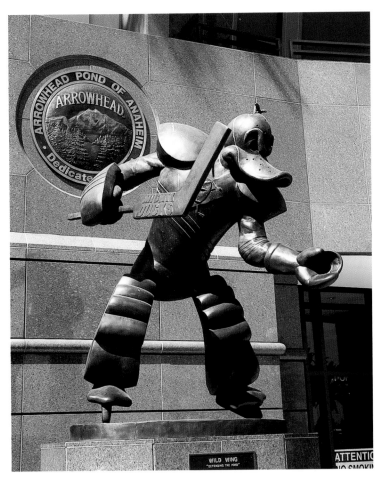

Left:

A duck in hockey garb greets fans at the entrance to Arrowhead Pond, home of the National Hockey League's Anaheim Mighty Ducks. Although the franchise has only been around since the mid-1990s, the Disney-owned Ducks have earned respect in hockey circles. The team reached the Stanley Cup finals in 2003. *Richard Carroll/California Stock Photo*

Below:

Staples Center is home to Los Angeles's three professional basketball teams (the Lakers, the Clippers, and the Sparks), its hockey team (the Kings), and its arena football team (the Avengers). *Peter Bennett/California Stock Photo*

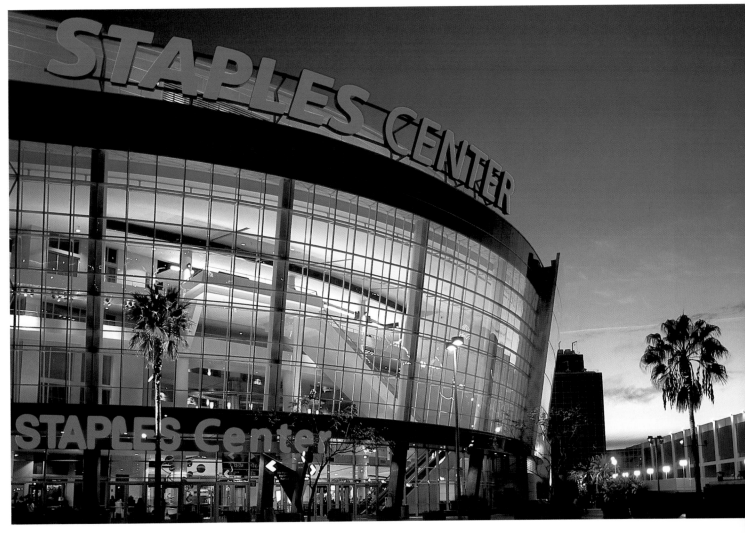

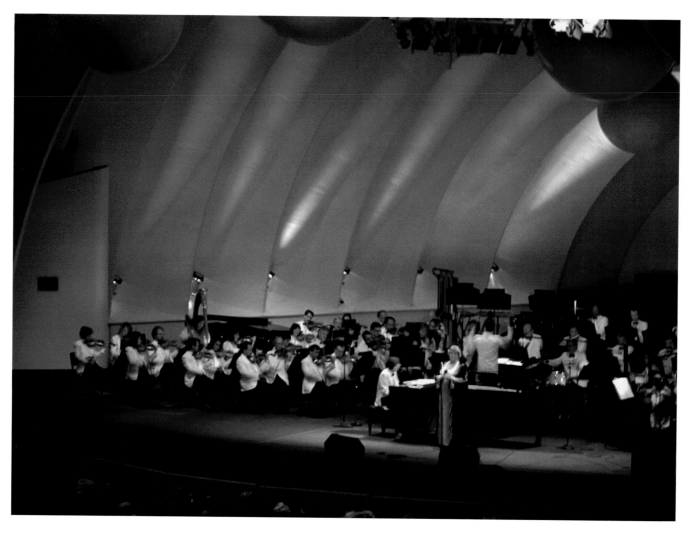

The Hollywood Bowl stage has been graced by many legendary performers from all musical genres since the venue first opened in 1922. In 1964, the Beatles became the first rock-and-roll act to play here. *Richard Carroll/California Stock Photo*

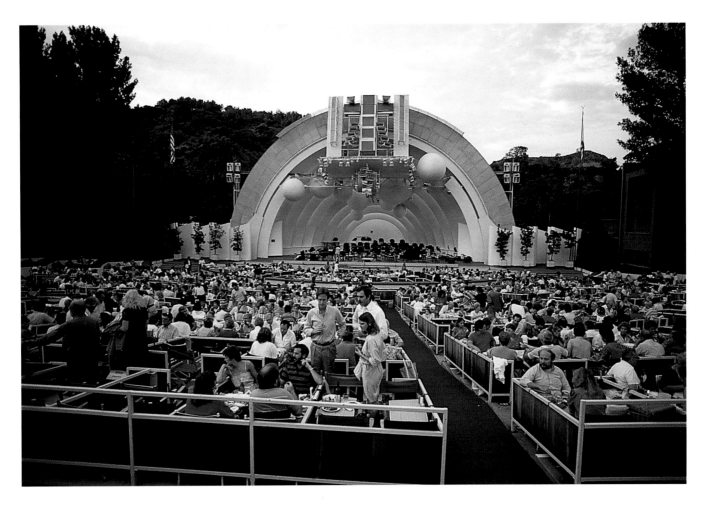

Above:

Concert-goers often arrive early at the Hollywood Bowl to enjoy a relaxing picnic dinner before the show. This is one of the largest natural amphitheaters in the world. *Richard Carroll/California Stock Photo*

On the overleaf:

The striking Walt Disney Concert Hall, dedicated on October 20, 2003, is the new home of the Los Angeles Philharmonic. Local architect Frank O. Gehry designed the futuristic building, characterized by clean lines and curved steel. *Larry Brownstein/California Stock Photo*

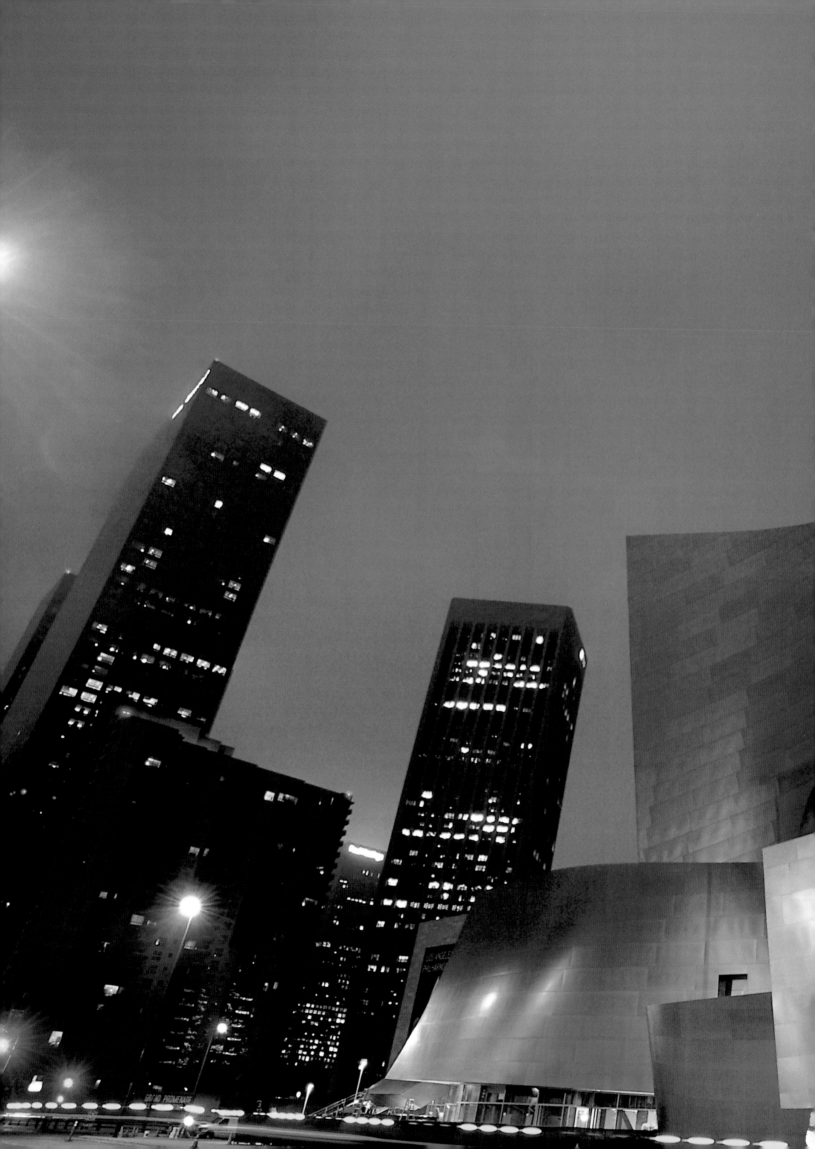

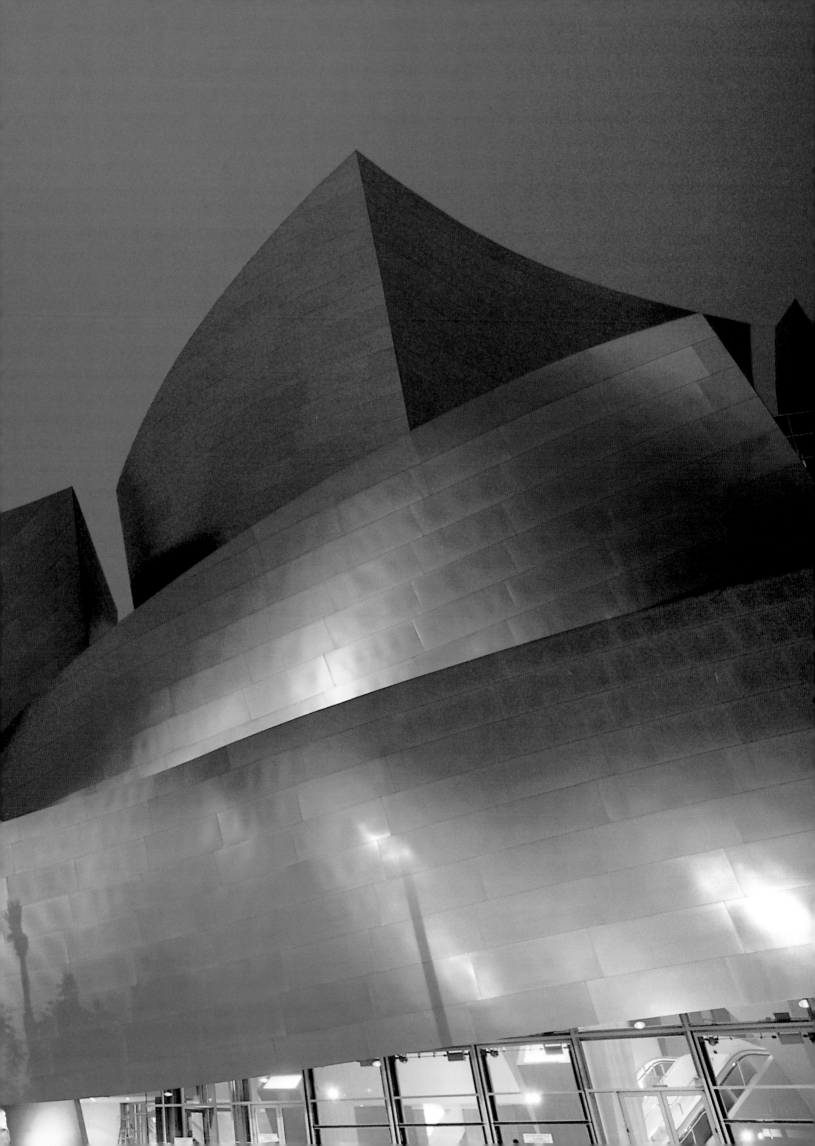

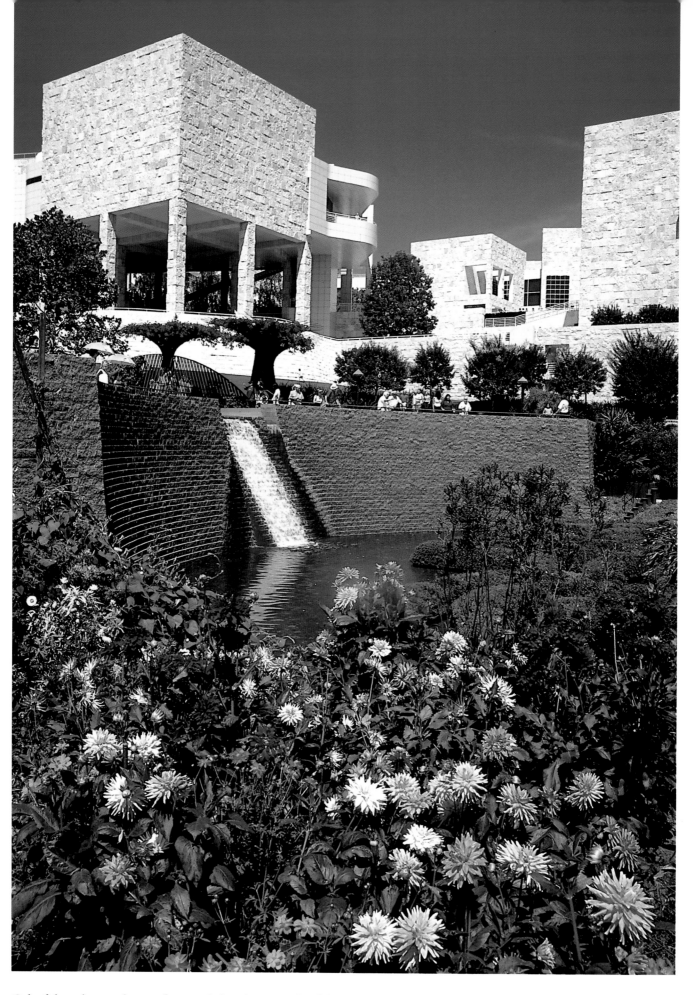

Colorful gardens and water features bring the grounds of the Getty Center to life. Located on a dramatic hilltop with views of the Pacific Ocean, the San Gabriel Mountains, and the Los Angeles cityscape, this six-building complex includes an art conservation institute, the Getty Research Institute, and the J. Paul Getty Museum. *Larry Brownstein/California Stock Photo*

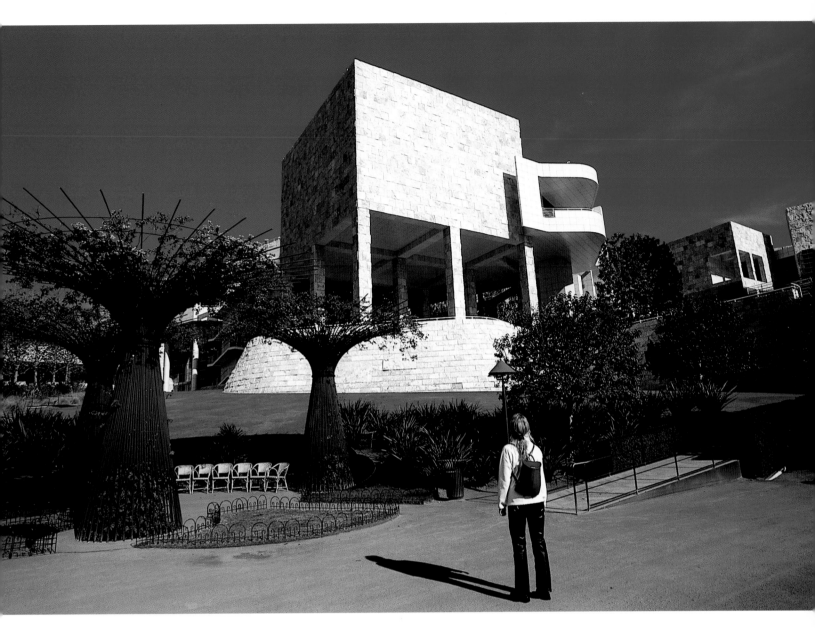

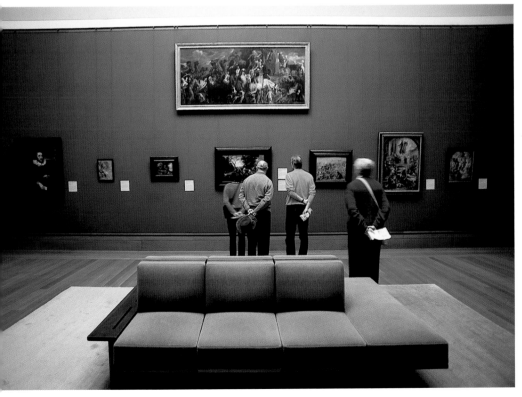

Above:
Architect Richard Meier designed the Getty Center around an open plaza, with extensive gardens incorporated throughout the grounds. Robert Irwin worked closely with Meier in laying out the elaborate Central Garden. *Peter Bennett/California Stock Photo*

Left:
The J. Paul Getty Museum at the Getty Center houses an impressive collection of world-renowned art, including paintings, drawings, sculpture, illuminated manuscripts, decorative arts, and photographs. *Peter Bennett/California Stock Photo*

Right:

The Anderson Building, a 1986 addition to the Los Angeles County Museum of Art (LACMA), glistens in the golden California sun. Home to more than 250,000 works of art, LACMA is one of the largest art museums in the country. *Larry Brownstein/California Stock Photo*

Below:

The sculpture garden at LACMA includes everything from dramatic modern sculptures to classic works by Rodin. *Larry Brownstein/California Stock Photo*

Facing page:

The original building of LACMA was erected in 1965 along Miracle Mile on Wilshire Boulevard. In addition to works by American, Southeast Asian, and Indian artists, the museum has an extensive collection of costumes and textiles. *Peter Bennett/California Stock Photo*

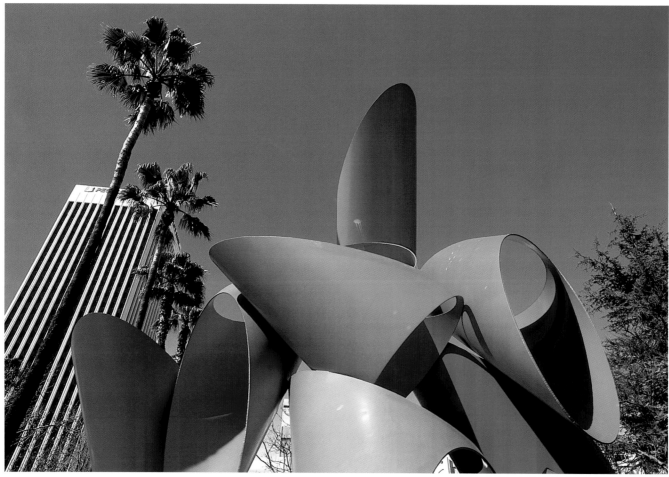

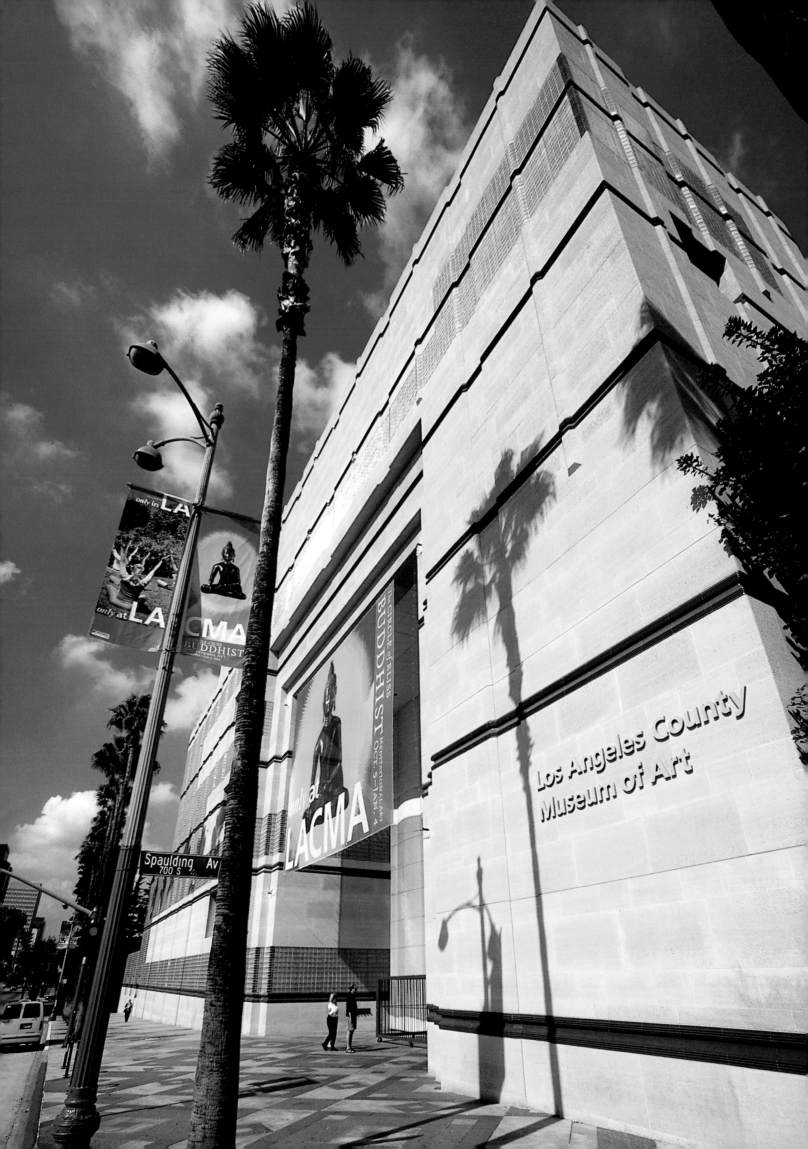

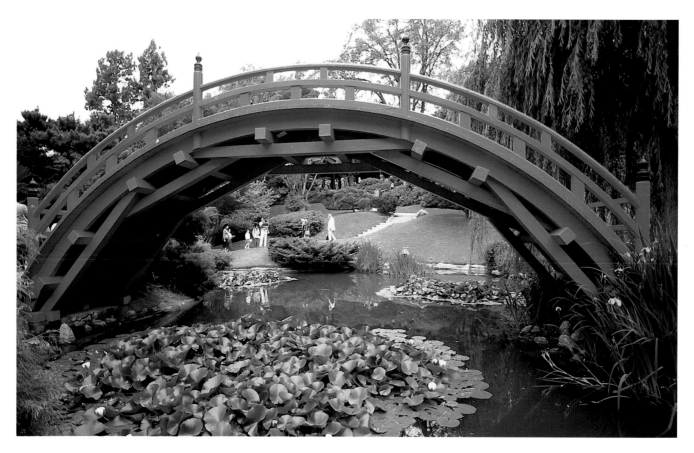

A red footbridge spans the tranquil lily pond in the Japanese garden at Huntington Botanical Gardens in San Marino. Inside the walled garden is a Zen garden, a bonsai court, and an authentic Japanese house. *Larry Brownstein/ California Stock Photo*

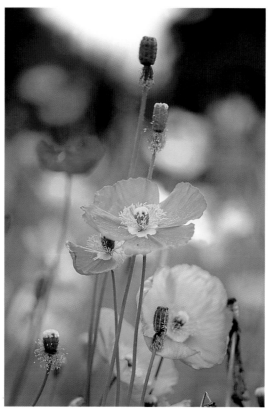

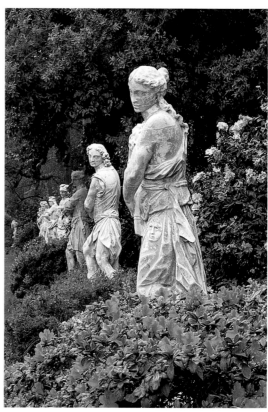

A bed of poppies, California's state flower, is part of the visual splendor at the Huntington Gardens. The expansive grounds include a desert garden, a Japanese garden, a palm garden, and a Shakespeare garden. *Larry Brownstein/ California Stock Photo*

Spanning nearly 150 acres, the Huntington Botanical Gardens displays a vast and impressive collection of plants. These classical sculptures stand amongst azalea and rose bushes. *Larry Brownstein/California Stock Photo*

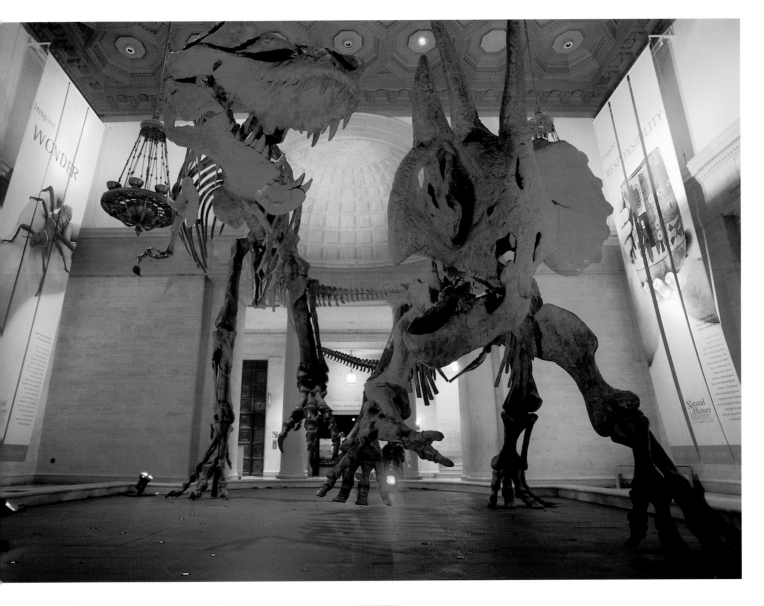

Above:

Dinosaur skeletons dominate the exhibits at the Natural History Museum of Los Angeles County in Exposition Park. The museum, which opened in 1913, is the largest natural history museum in the western United States, and it is an active research center. *Peter Bennett/California Stock Photo*

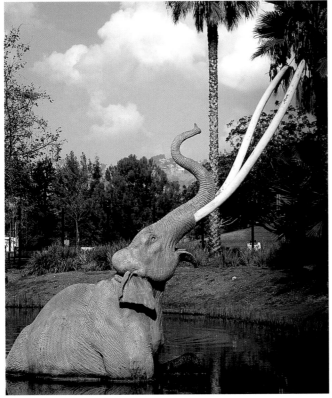

Left:

An elephant replica appears to trumpet from the depths of a pond in the La Brea Tar Pits at the Page Museum. In the late 1800s and early 1900s, bones and fossils of several Ice Age animals and plants were discovered in the black, tar-filled bogs of LA's Hancock Park. *Peter Bennett/California Stock Photo*

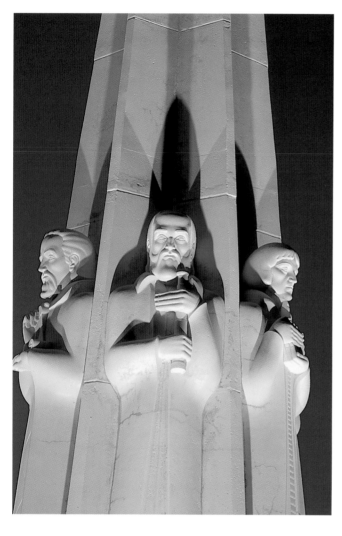

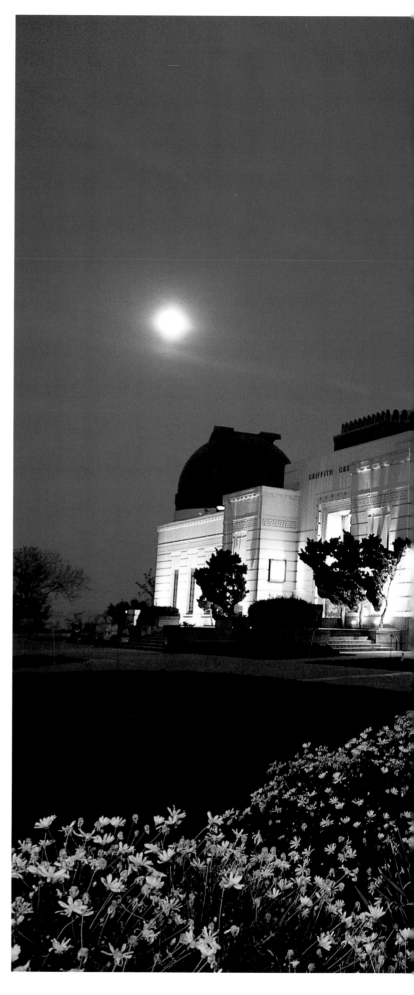

Above:

A miniature art deco obelisk featuring the likenesses of six great astronomers—Hipparchus, Copernicus, Galileo, Kepler, Newton, and Herschel—graces the expansive front lawn of Griffith Observatory. *Larry Brownstein/California Stock Photo*

Right:

Perched atop Mount Hollywood, Griffith Observatory commands a stunning view of both the heavens above and the city of Los Angeles in the valley below. Since it was completed in 1935, the observatory has been a top attraction for astronomy enthusiasts. It was made famous on the silver screen in the James Dean–Natalie Wood flick, *Rebel Without a Cause,* in 1955. *Larry Brownstein/California Stock Photo*

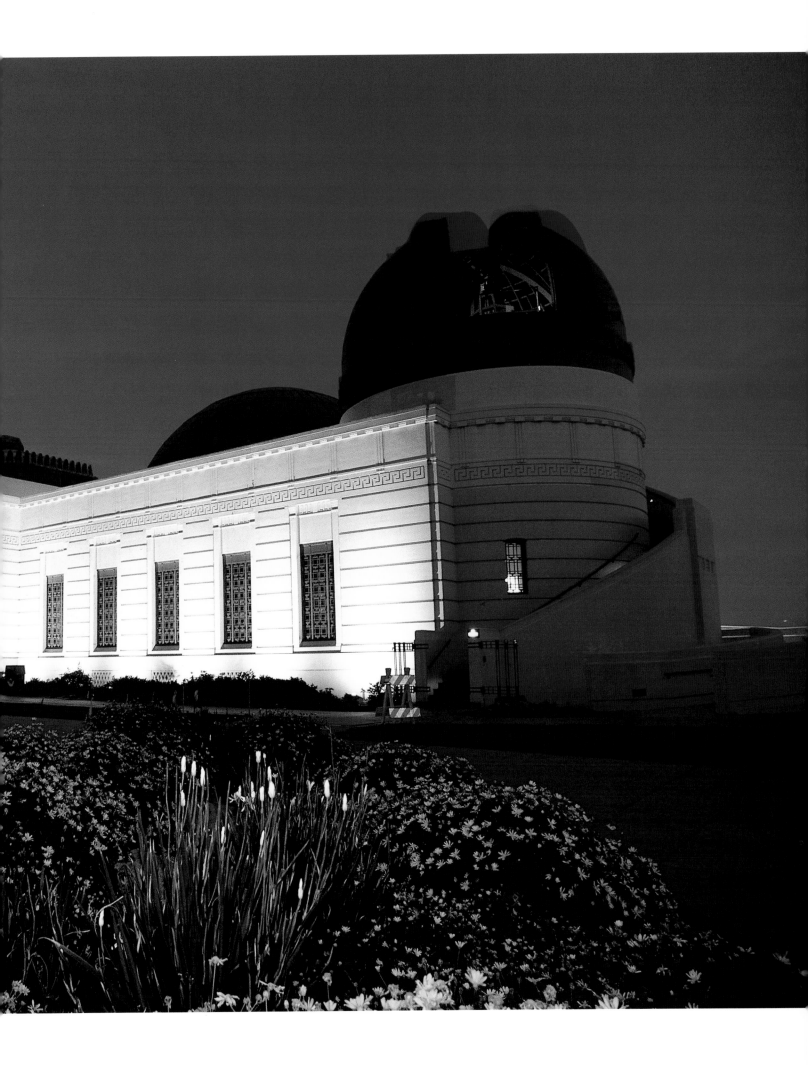

Architect brothers Charles and Henry Greene designed several notable homes in the city of Pasadena. The Gamble House was built in 1908 as a vacation home for an heir to the Proctor and Gamble fortune. The bungalow embodies the popular Arts and Crafts style of the time, from the eaves down to the interior furnishings. *Richard Carroll/California Stock Photo*

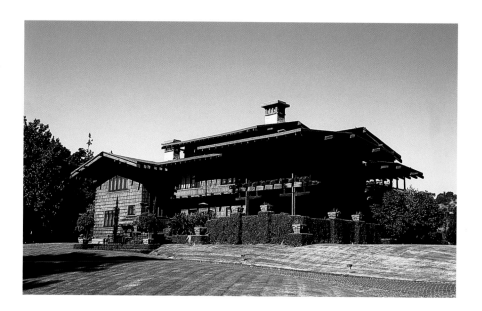

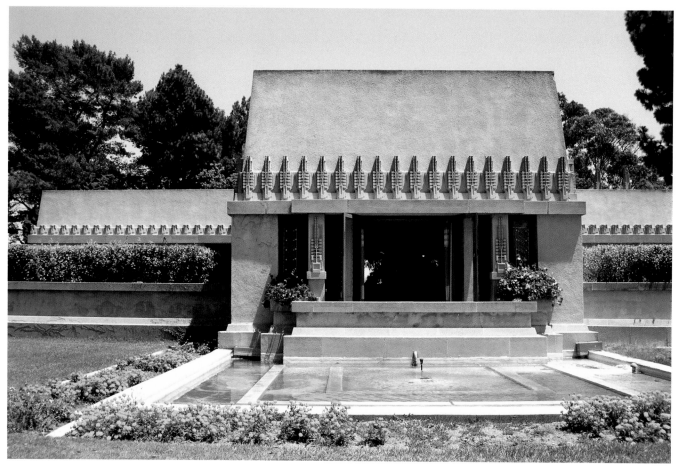

Above:

Hollyhock House, the first home designed by Frank Lloyd Wright in the Los Angeles area, was built for oil heiress Aline Barnsdall in about 1920 in Barnsdall Park. Hollyhock flower designs embellish both the exterior and interior of the pre-Columbian-style home. *Richard Carroll/California Stock Photo*

Facing page:

The world-famous Watts Towers gradually ascended into the skies above 107th Street in the Watts neighborhood between 1921 and 1954. Italian immigrant Simon Rodia built the towers by himself, using chicken wire, discarded steel, concrete, glass, tile, shells, and broken pottery, as a tribute to America. The highest tower is nearly 100 feet tall. *Larry Brownstein/California Stock Photo*

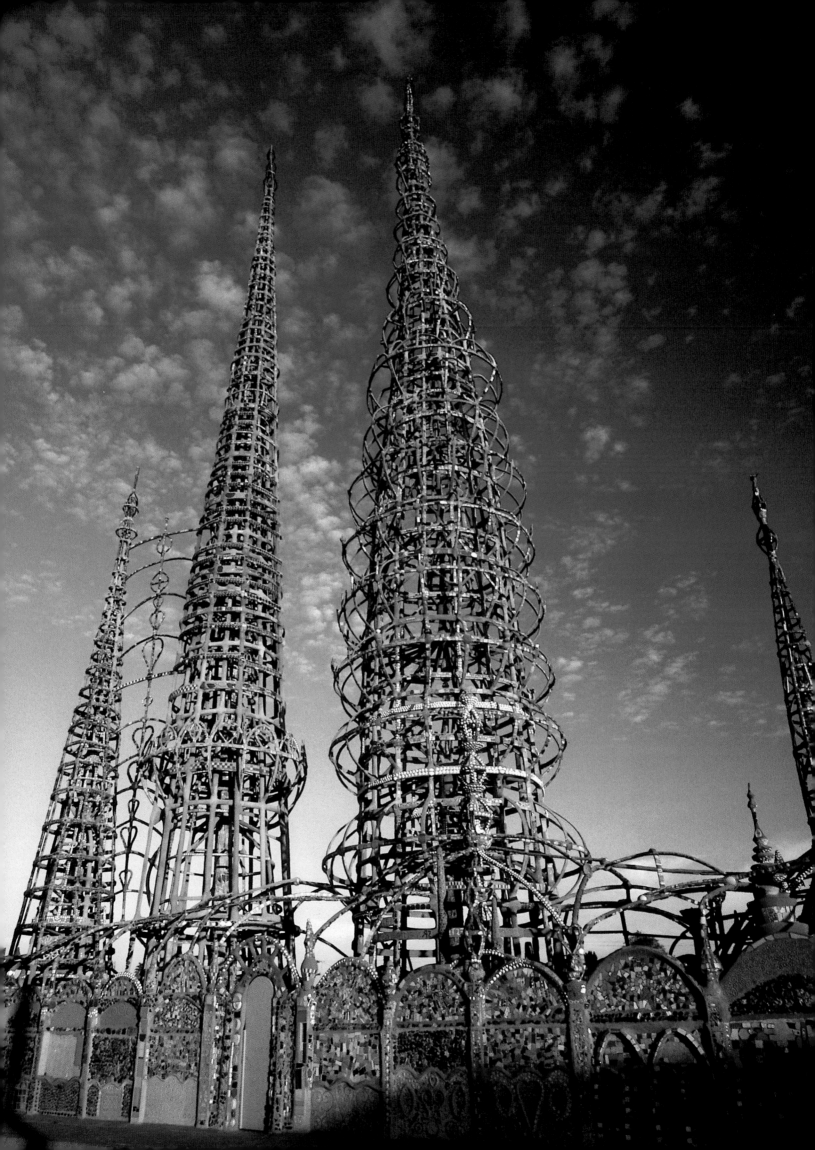

A toddler is entranced by *Unbridled,* a mural by David S. Gordon that decorates a wall along Ocean Park Boulevard in Santa Monica. *Richard Carroll/ California Stock Photo*

Many vibrant Chicano murals adorn walls throughout East LA. *Tree of Knowledge,* painted by multiple artists in 1978, can be seen at the Anthony Quinn Public Library along Cesar Chavez Avenue. *Richard Carroll/California Stock Photo*

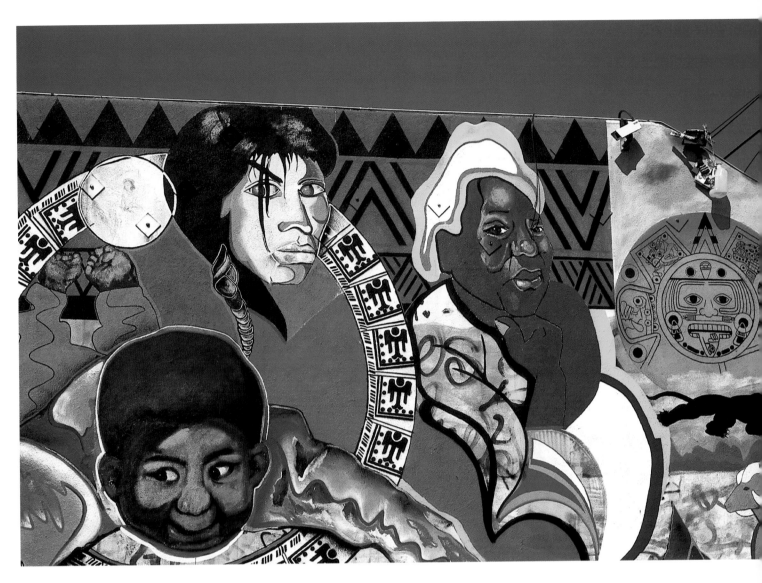

Above:

More than 1,500 murals, depicting a wide variety of topics in many mediums, grace the streets of Los Angeles. This mural in Venice, called *Seeds by the Sea,* is the work of a number of artists. *Richard Carroll/ California Stock Photo*

Left:

The diverse ethnic makeup of Los Angeles is evident in the public artwork found throughout the city. Eliseo Art Silva's *Toward a Better and More Beautiful World* in West LA celebrates Jewish-American culture, history, and traditions. *Larry Brownstein/California Stock Photo*

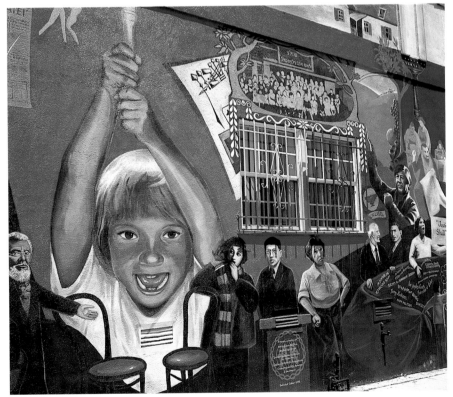

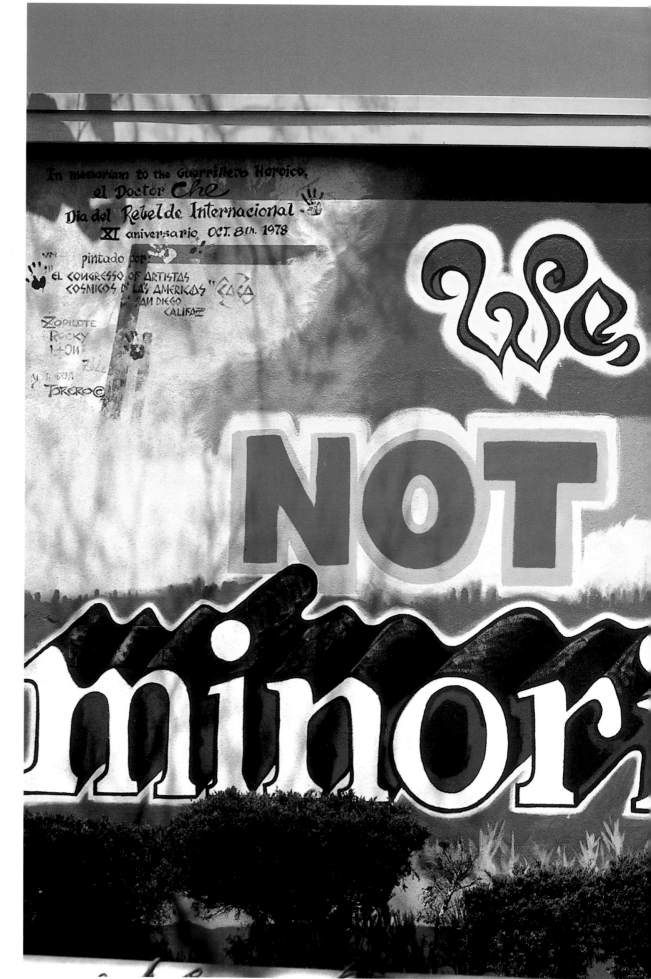

Painted on a wall in East LA's Estrada Courts, *We Are Not a Minority* honors Che Guevara, a famous Latin American revolutionary and a hero to many Latinos in the United States. The mural was painted in 1978 by artists who participated in the Chicano Park struggle in San Diego. It was restored by Mario Torero and Carmen Kalo in 1996. *Richard Carroll/ California Stock Photo*

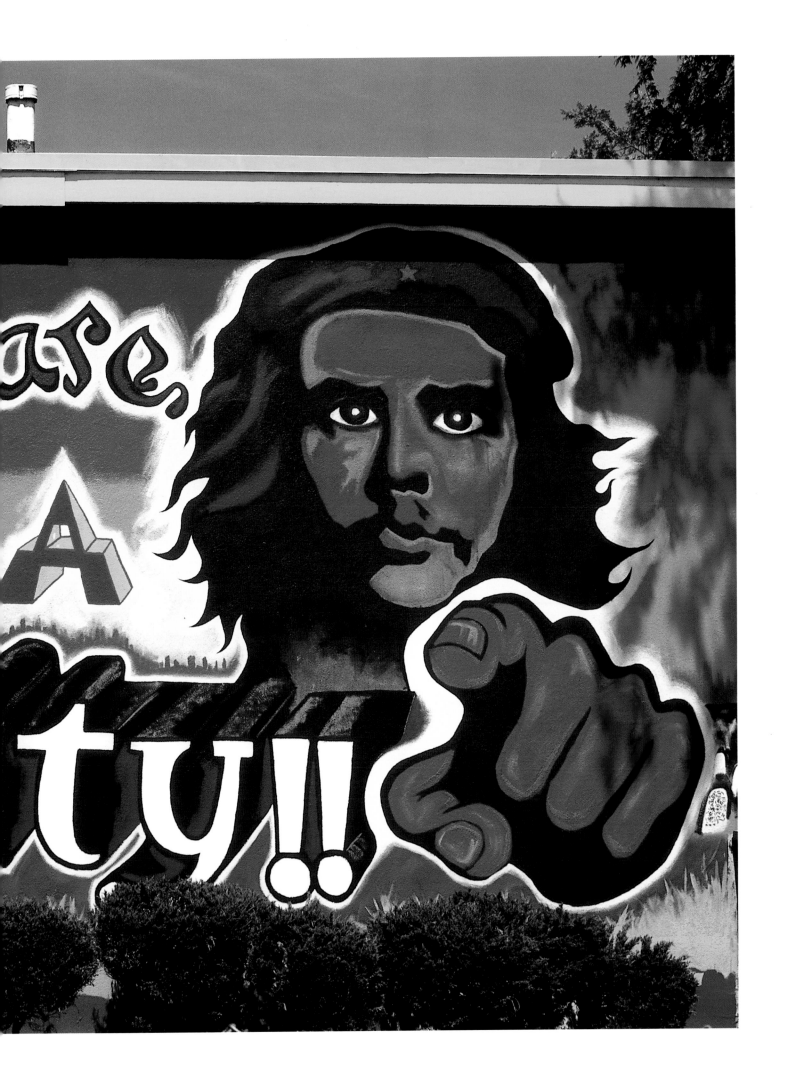

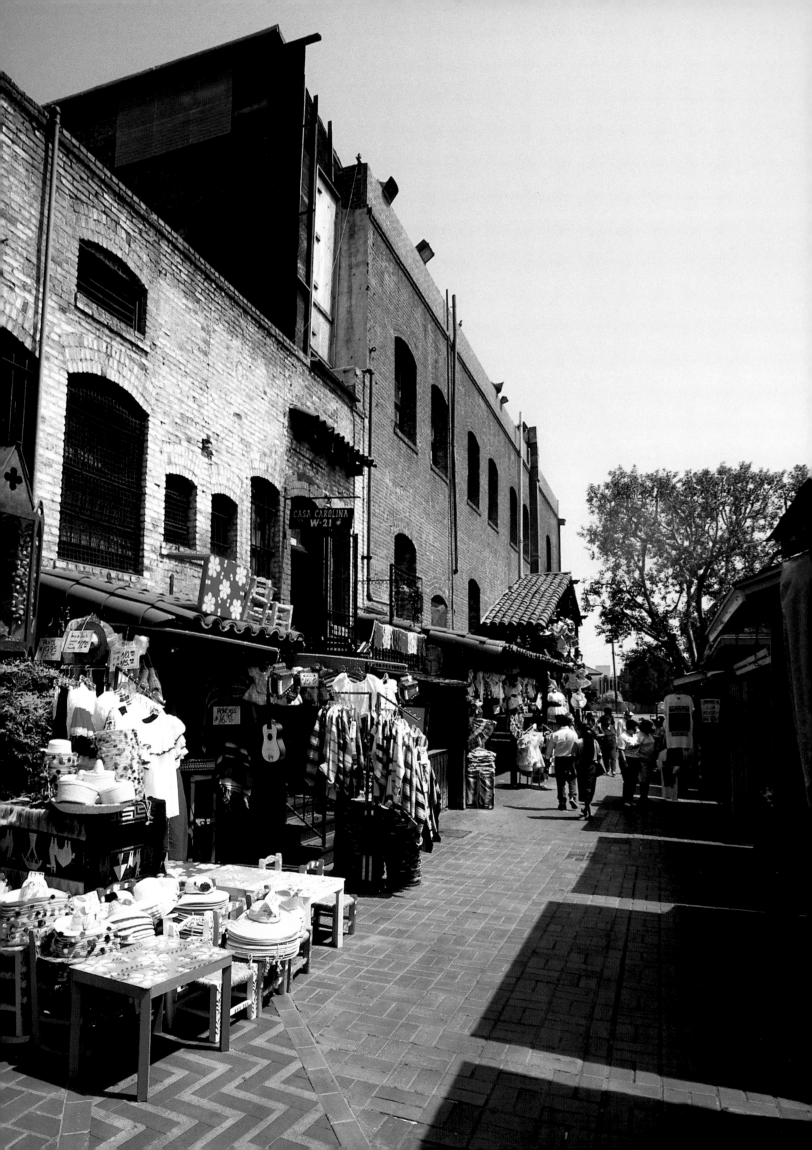

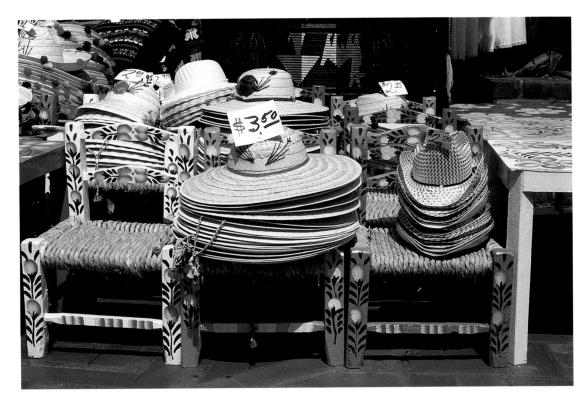

Straw hats and colorfully painted furniture beckon to shoppers along Olvera Street. The souvenirs and Mexican handicrafts are popular attractions for locals and tourists alike. *Richard Carroll/California Stock Photo*

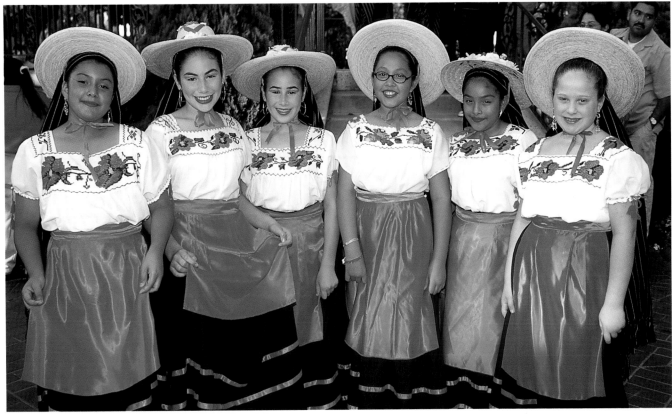

Above:
Young girls in traditional Mexican dress entertain tourists at El Pueblo de Los Angeles Historic Monument, the birthplace of Los Angeles. *Richard Carroll/California Stock Photo*

Facing page:
El Pueblo de Los Angeles Historic Monument preserves the adobe buildings of the farming community that eventually evolved into modern-day Los Angeles. The oldest buildings in the district date back to the early 1800s. Olvera Street, lined with Mexican shops and restaurants, lies at the center of El Pueblo. *Richard Carroll/California Stock Photo*

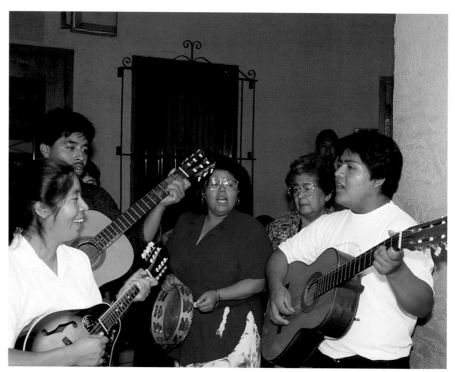

Musicians can be found roaming the streets of El Pueblo, adding to the festive and authentic atmosphere. *Richard Carroll/California Stock Photo*

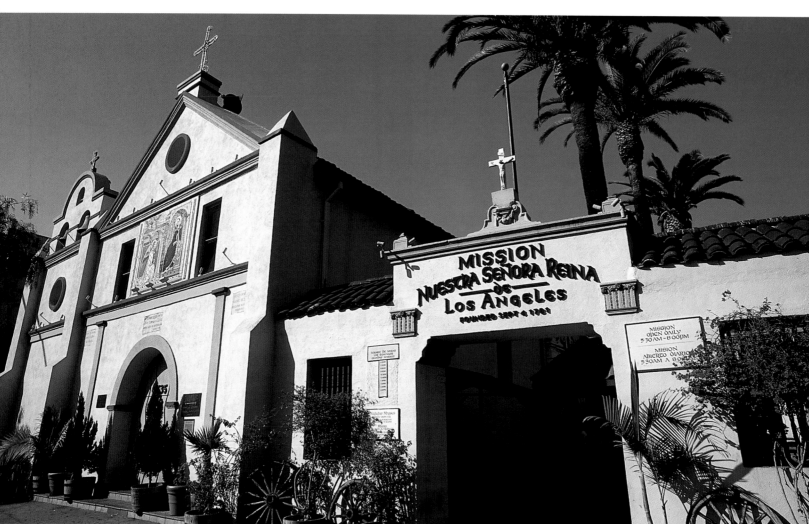

La Iglesia de Nuestra Señora La Reina de Los Angeles is the oldest church in the city of Los Angeles, dedicated on December 8, 1822. Unlike most California missions that later developed into towns, Mission Nuestra Señora Reina was built as a church after the settlement of El Pueblo de Nuestra Señora La Reina de Los Angeles grew up around it. *Peter Bennett/ California Stock Photo*

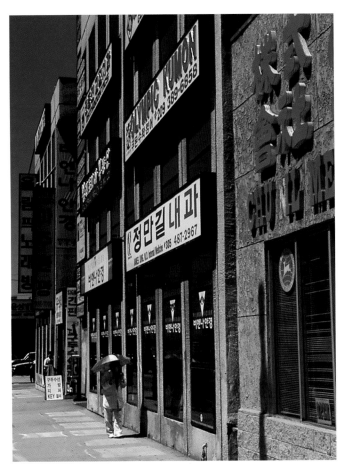

Left:

Los Angeles County is home to the largest Korean population, amounting to nearly 200,000 people. One-third of Los Angeles's Koreans and Korean-Americans live in Koreatown, a center for Korean stores and restaurants. *Richard Carroll/California Stock Photo*

Below:

Los Angeles recognized Koreatown as a separate community in 1970, when fewer than 10,000 people lived there. Today, the Korean settlement is larger than the city's Chinatown. *Peter Bennett/California Stock Photo*

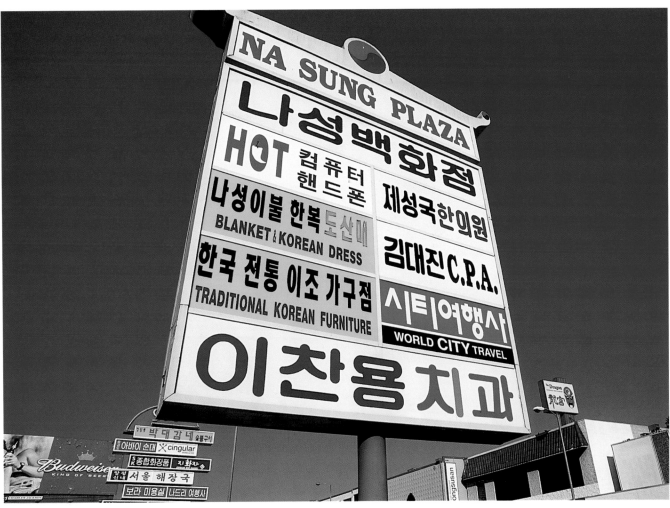

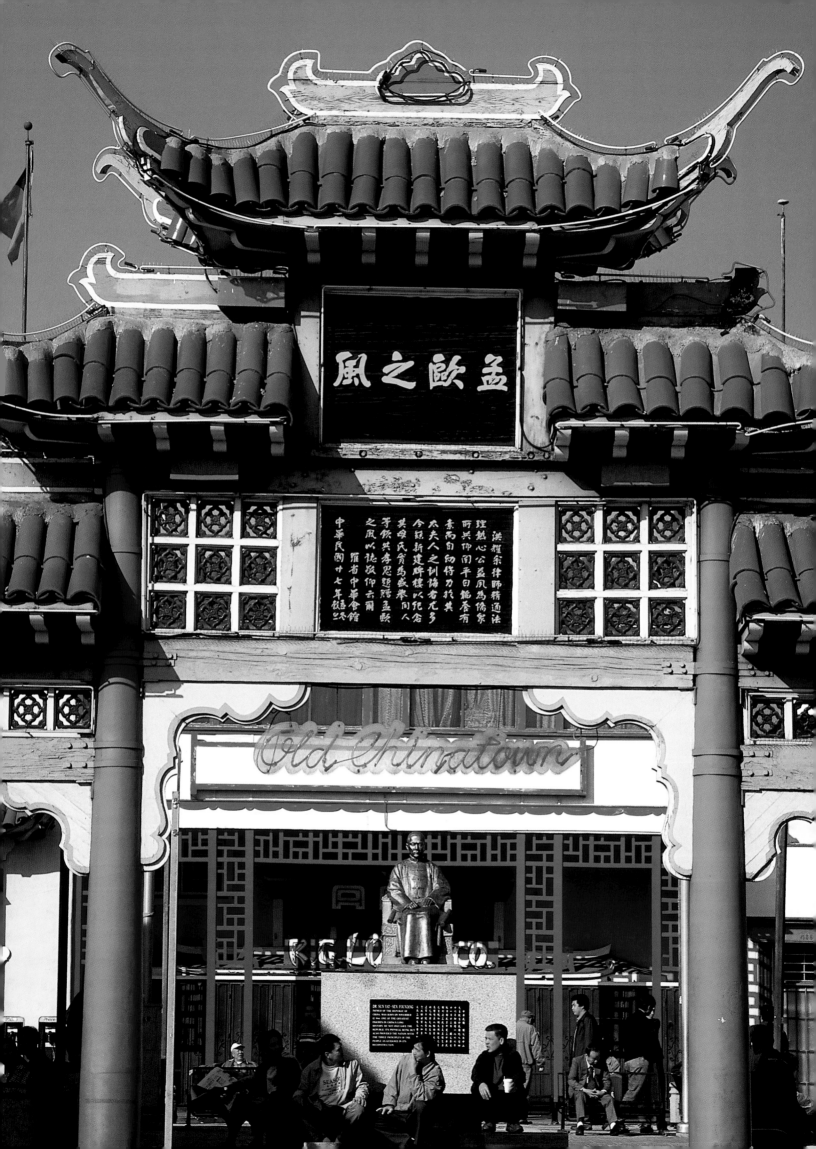

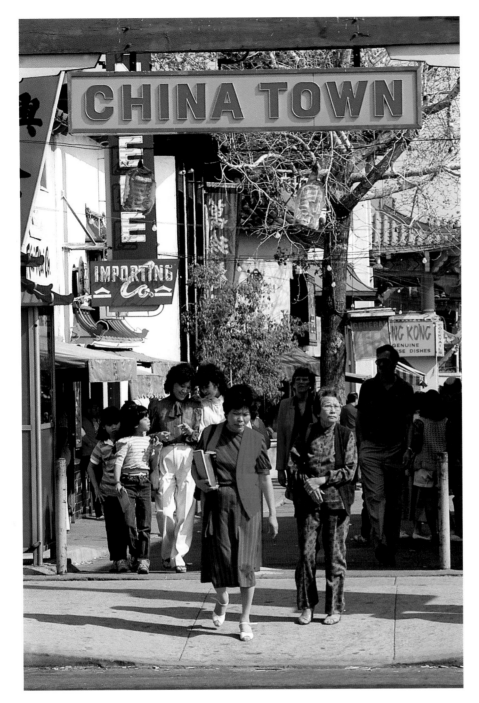

Facing page:

The earliest Chinese settlements in Los Angeles were established in the 1850s, and the population grew steadily through the early decades of the twentieth century. The original Chinatown was destroyed to make way for Union Station in the late 1930s, and the settlement relocated to its current location along Broadway. The main gateway on North Broadway opens onto the Central Plaza, which features a monument to Dr. Sun-Yet Sen. *Peter Bennett/California Stock Photo*

Top left:

Chinatown remains a center for Chinese grocery stores, restaurants, herb shops, and curio shops. In recent years, many Chinese immigrants have moved to Monterey Park, but continue to shop, eat, and do business in Chinatown. *Richard Carroll/ California Stock Photo*

Bottom left:

Plaques and signs in Chinese mark historic buildings, stores, and restaurants throughout Chinatown. *Larry Brownstein/California Stock Photo*

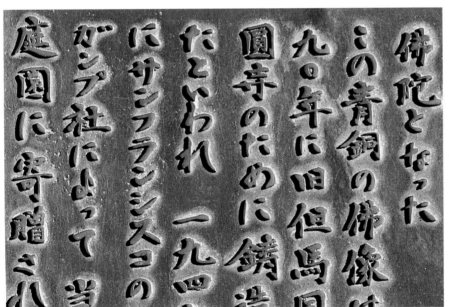

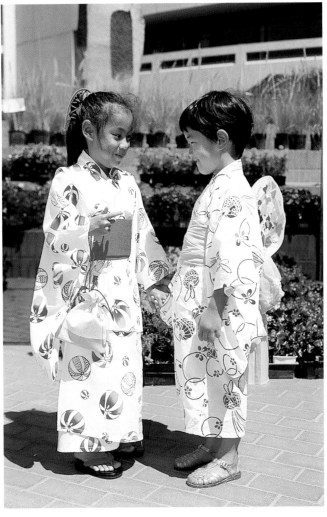

Above:

Children dressed in brightly patterned kimonos play in one of Little Tokyo's sunlit gardens. Little Tokyo got its name shortly after 1900, when thousands of Japanese immigrants relocated to Los Angeles from San Francisco to work on the railroads. *Richard Carroll/California Stock Photo*

Left:

The Garden in the Sky, a half-acre Japanese garden on the terrace of the New Otani Hotel in Little Tokyo, provides a quiet place for contemplation in downtown Los Angeles. The garden features a waterfall, a narrow pond, stone lanterns, and other traditional Japanese elements. *Peter Bennett/California Stock Photo*

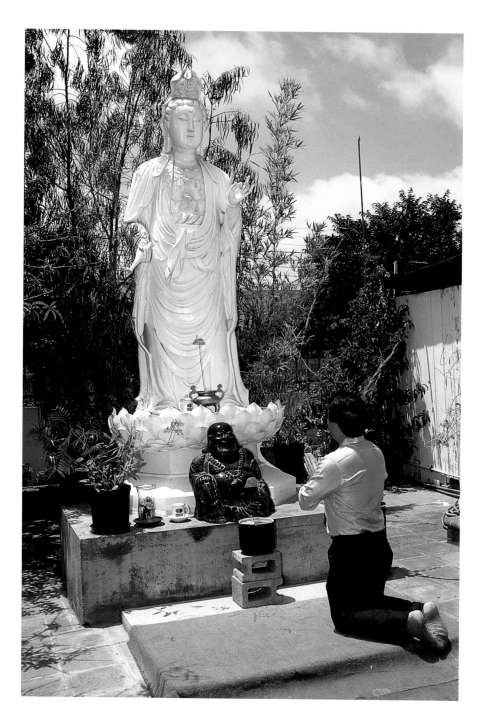

A member of LA's Vietnamese community worships at an outdoor shrine in Little Saigon, in Westminster, Orange County. *Richard Carroll/California Stock Photo*

Ornately painted floral motifs adorn the ceiling of King Fahd Mosque in Culver City. Built in 1998, the mosque can accommodate 2,000 worshippers at a time. *Larry Brownstein/California Stock Photo*

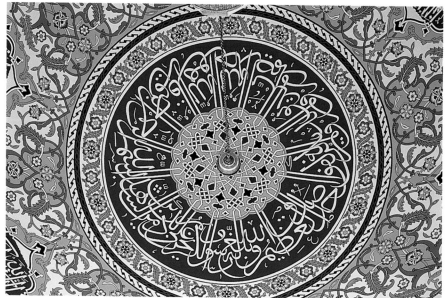

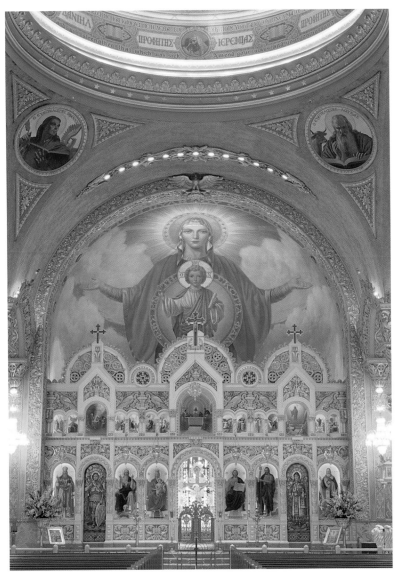

Left:

Bathed in golden light, the Virgin Mary (Theotokos) and baby Jesus adorn the ceiling over the Holy Altar in Saint Sophia Greek Orthodox Cathedral in Los Angeles. The spectacular cathedral was built in the 1950s, when the location on South Normandie Avenue was the city's main Greek neighborhood. *Larry Brownstein/California Stock Photo*

Below:

Orthodox Jews in West Hollywood gather for an outdoor Torah dedication. The Los Angeles metropolitan area is home to the second-largest Jewish population in the world, after New York City. *Larry Brownstein/ California Stock Photo*

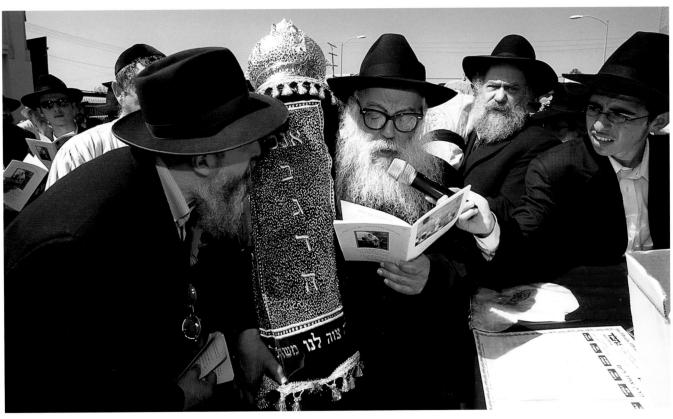

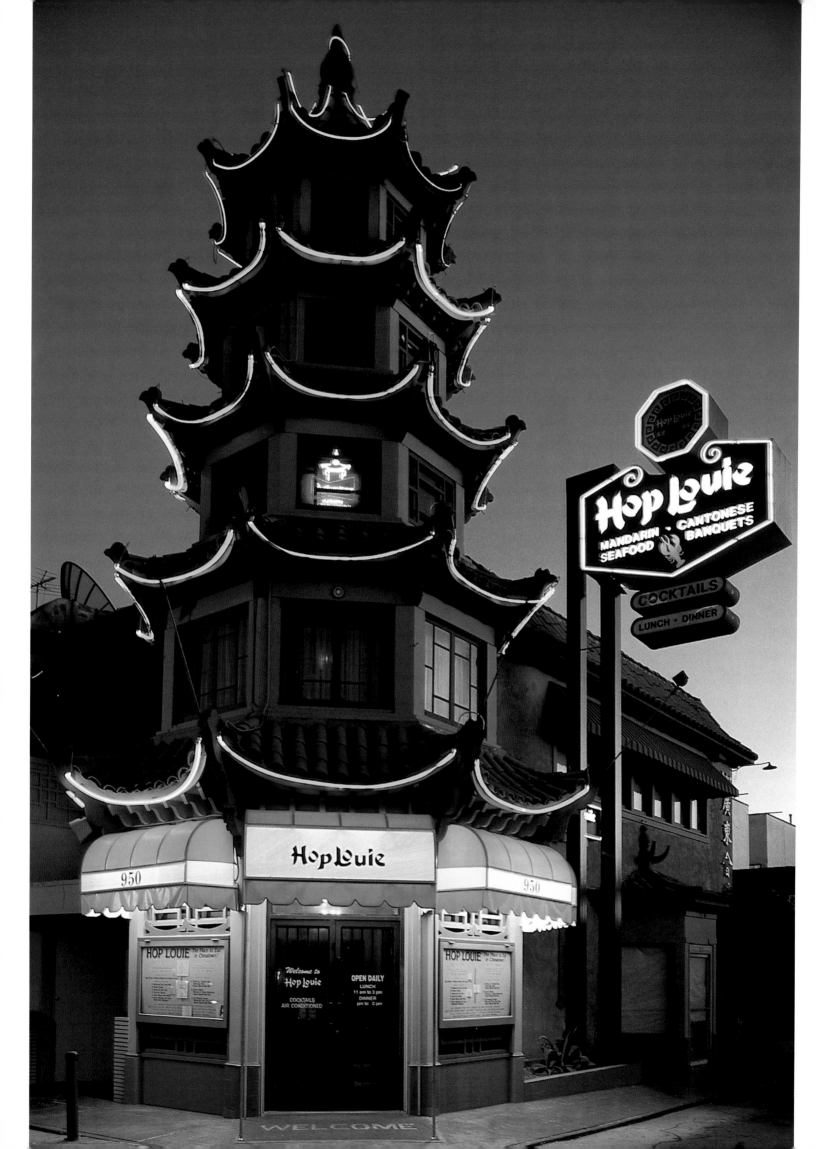

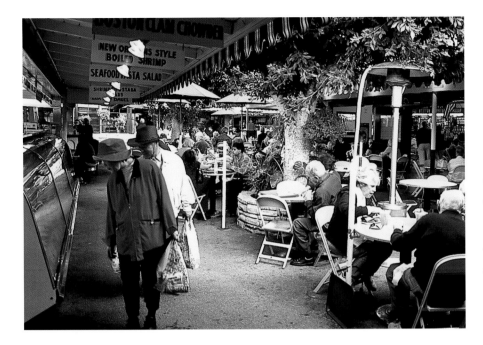

The open-air farmer's market on Third and Fairfax, opened in 1934, is a Los Angeles institution. Customers work the aisles, buying fresh fruits, vegetables, just-baked pies, and international delicacies. *Peter Bennett/ California Stock Photo*

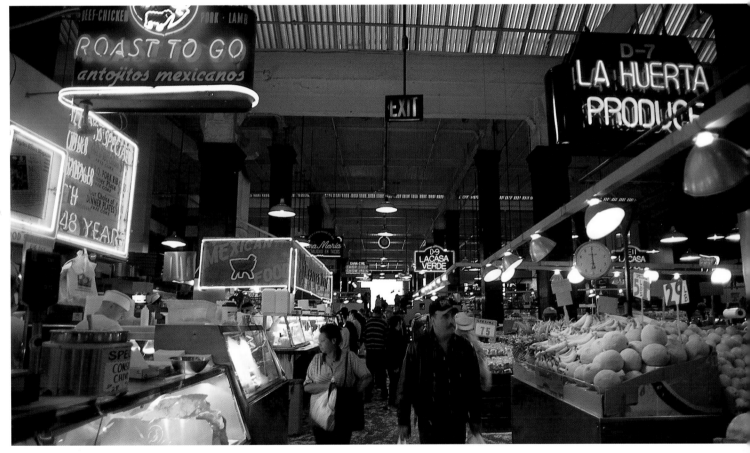

Above:

Angelenos have shopped Grand Central Market, a rambling indoor food market in downtown Los Angeles, since 1917. Fresh produce, flowers, meat, seafood, and spices are available for purchase, but vendors also sell a wide variety of hot eats, including everything from burritos to chop suey. *Peter Bennett/California Stock Photo*

Facing page:

The five-tier pagoda of Hop Louie restaurant towers over Central Plaza in Chinatown. Previously known as the Golden Pagoda, the restaurant was built in 1941. Tasty meals can be easily found at Chinatown's many restaurants. *Peter Bennett/ California Stock Photo*

Right:

The Venice Beach boardwalk is a lively place where artists, performers, and budding entrepreneurs entice and entertain passersby. Venice has been home to a thriving art community since the 1960s. *Peter Bennett/ California Stock Photo*

Below:

Palm trees and blue skies provide the perfect backdrop to this colorful graffiti work in progress on Venice Beach. *Larry Brownstein/California Stock Photo*

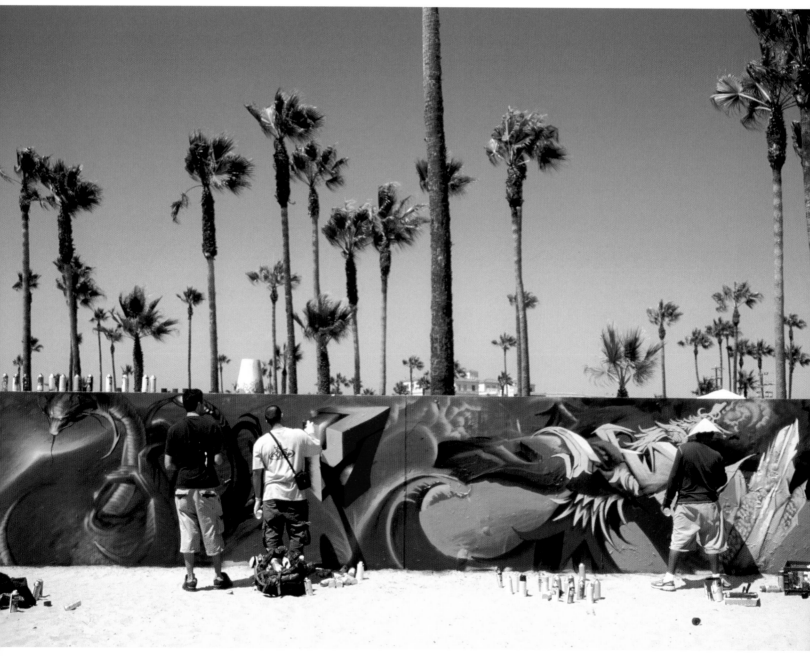

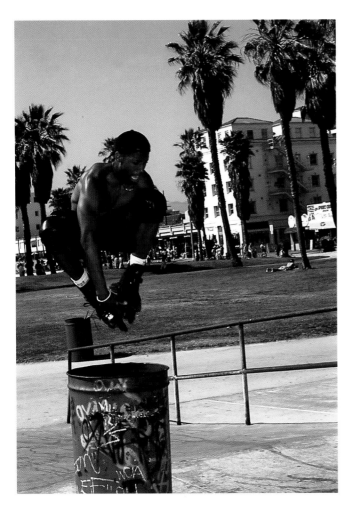

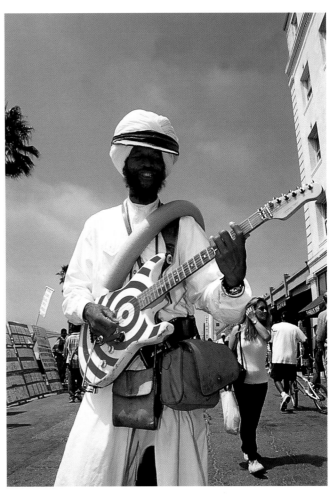

Rollerbladers abound along the boardwalk, whether showing off fancy moves or simply out for some leisurely fun. Venice was named the roller-skating capital of America in the 1970s. *Richard Carroll/California Stock Photo*

Creative and colorful characters make Venice an ideal place for people-watching. This roller-skating guitar player is a familiar sight on the boardwalk. *Larry Brownstein/California Stock Photo*

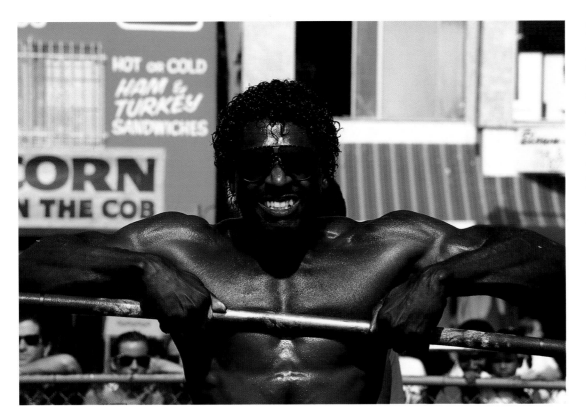

Body builders pump iron before droves of onlookers at Venice's Muscle Beach. Toned and buff bodies have been congregating here since the 1960s. *Peter Bennett/California Stock Photo*

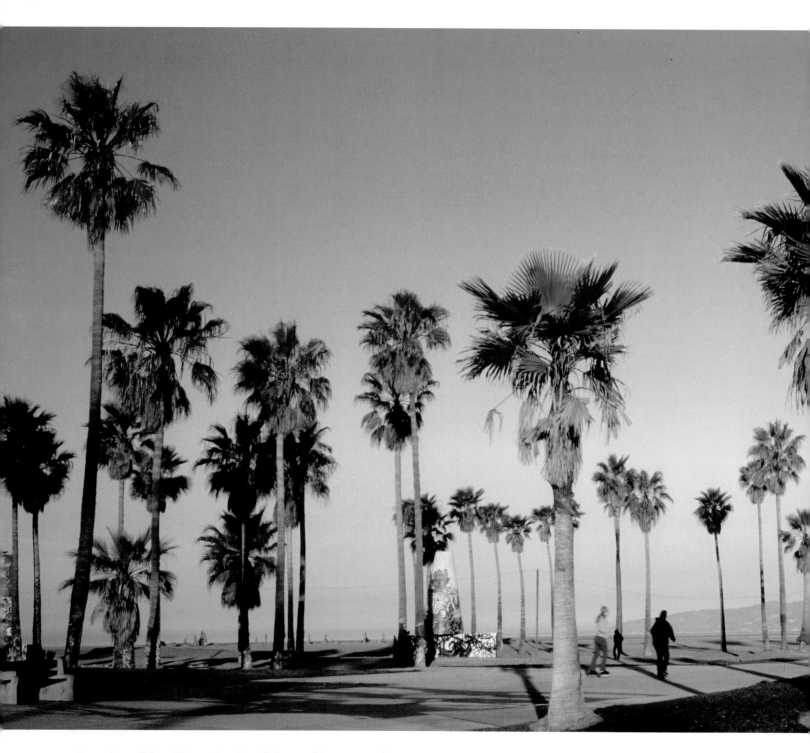

Ever since Abbot Kinney developed the seaside community as an American version of Italy's famous canal city in 1905, Venice has been a haven for Californians who want to relax. *Larry Brownstein/California Stock Photo*

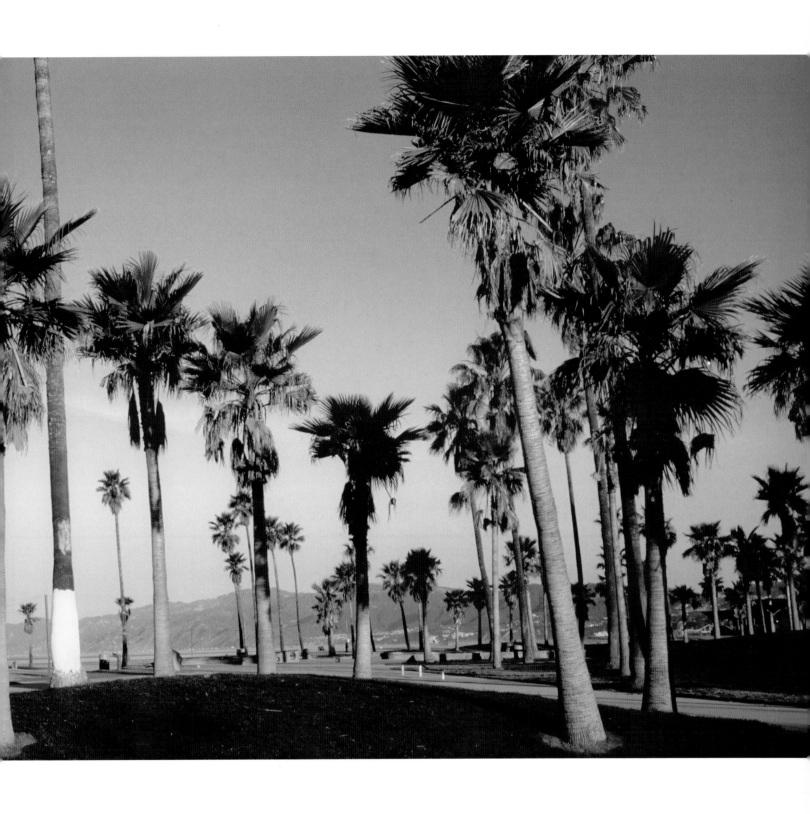

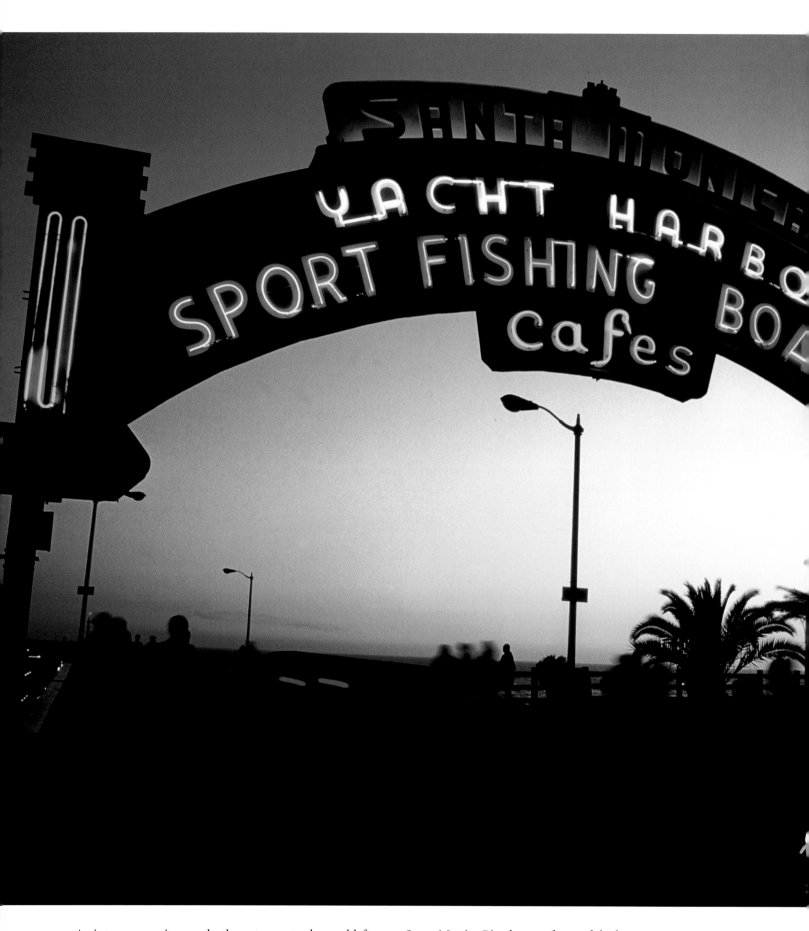

A vintage neon sign marks the entrance to the world-famous Santa Monica Pier, home of one of the best amusement parks on the West Coast. The pier also marks the end of America's legendary Route 66. *Mark E. Gibson/California Stock Photo*

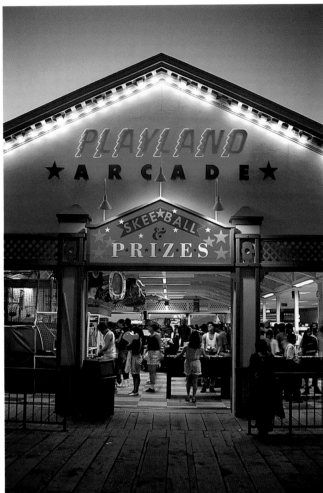

The Santa Monica Pier is a popular hangout for kids and adults alike on warm summer nights. The Playland Arcade offers the latest games as well as classics like Pac Man and pinball. *Larry Brownstein/ California Stock Photo*

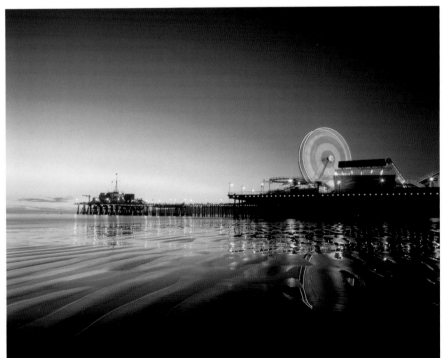

The festive lights of the spinning Ferris wheel at Pacific Park on Santa Monica Pier complement the deep sunset. Millions of visitors come to the oceanfront amusement park every year. *Anthony Arendt/California Stock Photo*

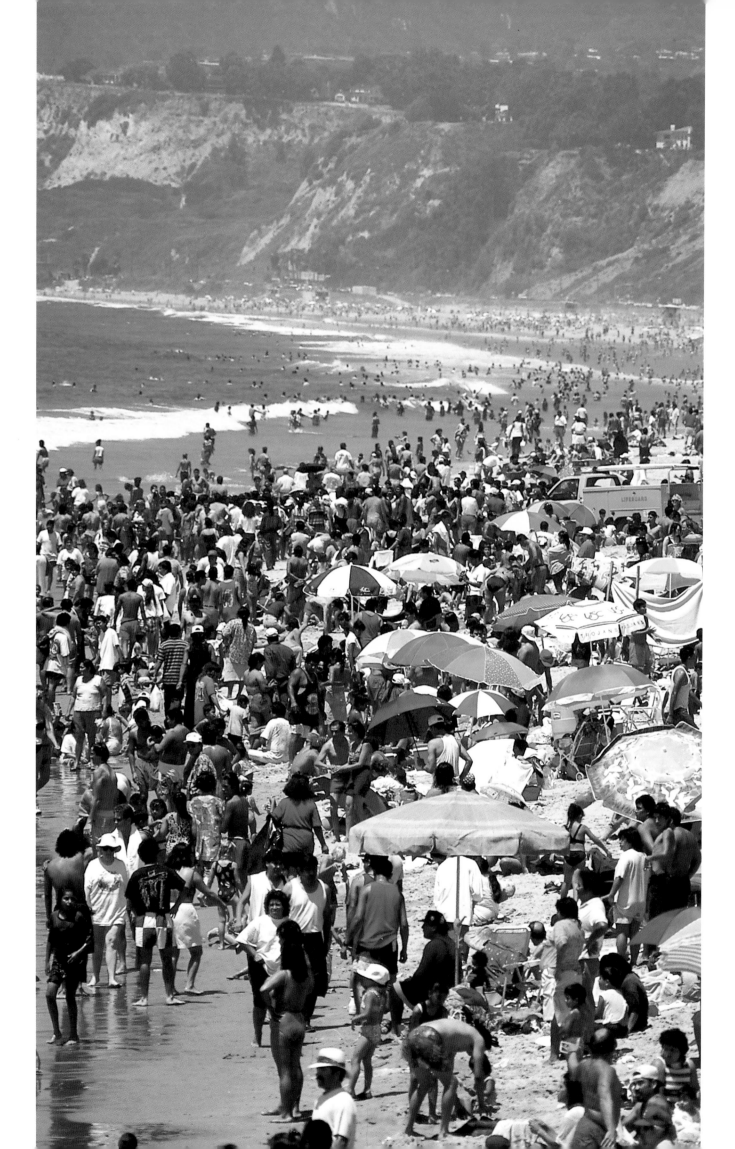

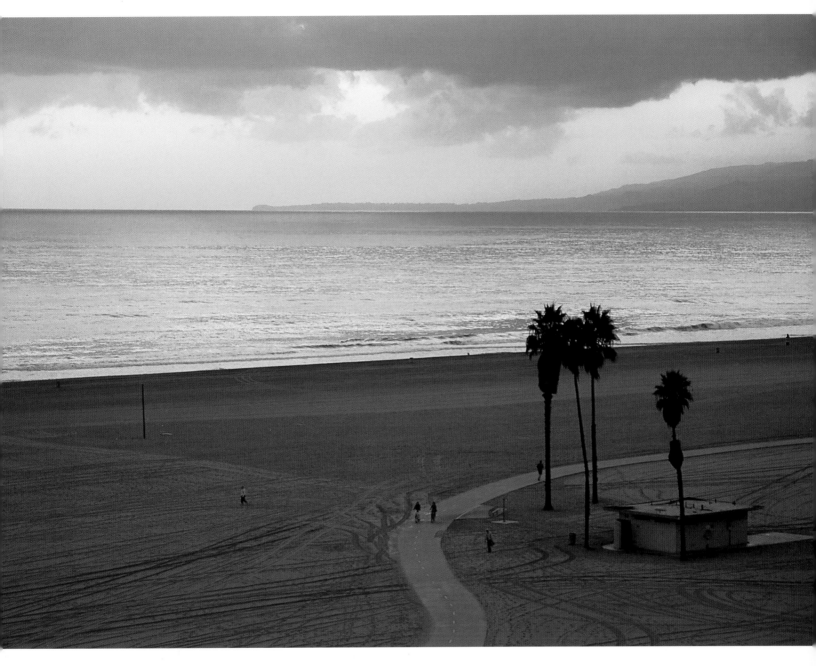

Above:
After the daytime crowds recede, the Santa Monica bicycling and walking path is a peaceful place to enjoy the sunset. *Peter Bennett/California Stock Photo*

Facing page:
Sun worshippers pack Santa Monica beach on hot summer days. The city of Santa Monica, surrounded on three sides by Los Angeles and by the Pacific Ocean on the fourth, was established in the 1870s and has been a bustling seaside community since the 1920s. *Larry Brownstein/California Stock Photo*

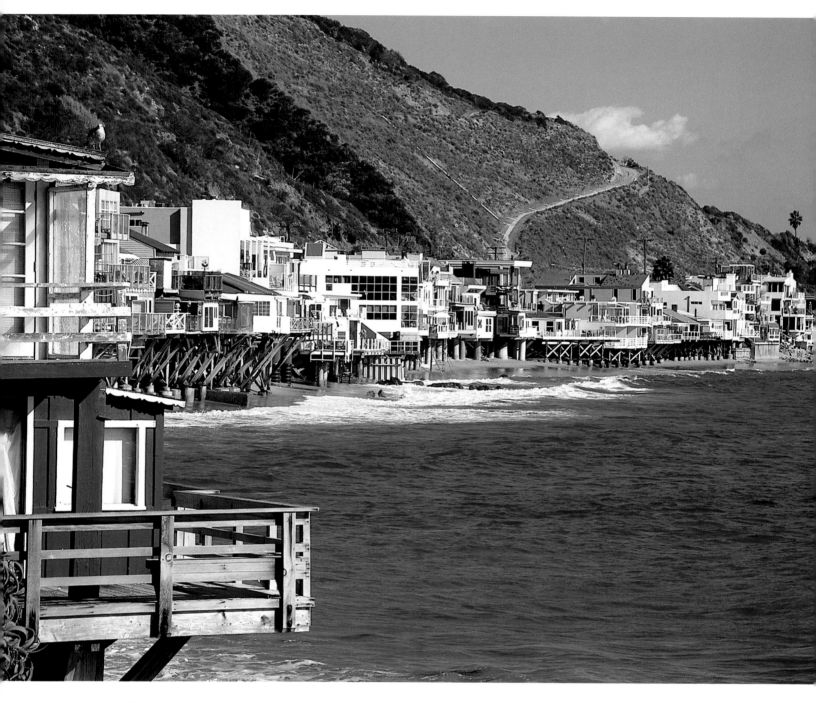

Pricey beach homes jut into the ocean along the highly desirable Malibu coastline. When movie stars began building homes here in the 1930s, the area came to be known as the "Malibu Movie Colony." Today, the nickname "The Colony" still holds. *Peter Bennett/California Stock Photo*

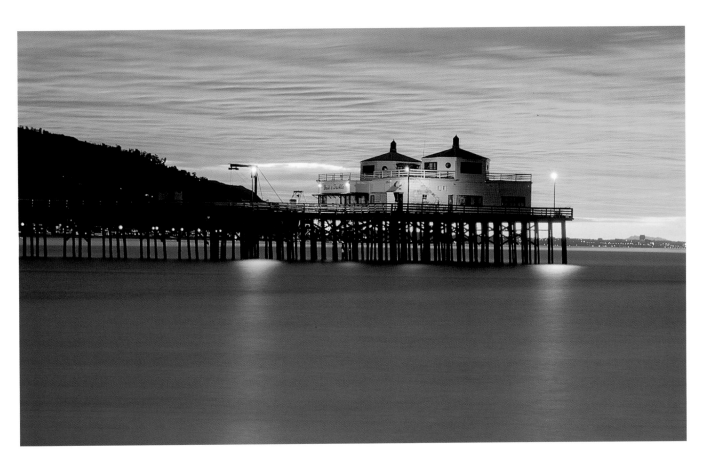

Twenty-six miles west of the hustle and bustle of downtown Los Angeles, Malibu pier seems a world away. *Larry Brownstein/California Stock Photo*

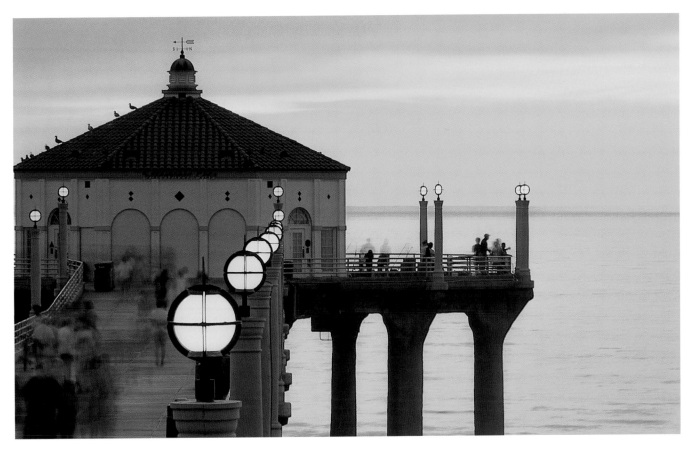

The pier at Manhattan Beach is a popular place to fish for barracuda, halibut, and yellowtail. It has been rebuilt three times due to pounding surf and corrosive saltwater. *Larry Brownstein/California Stock Photo*

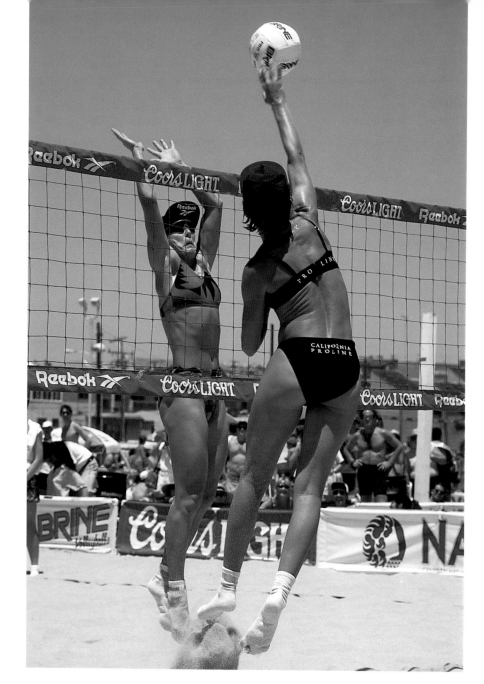

Right:

Beach volleyball is a highly competitive activity in southern California. Men's and women's tournaments are held regularly on Manhattan Beach. *Larry Brownstein/California Stock Photo*

Below:

Budding surfers frolic in the sea off the Malibu coast. *Larry Brownstein/ California Stock Photo*

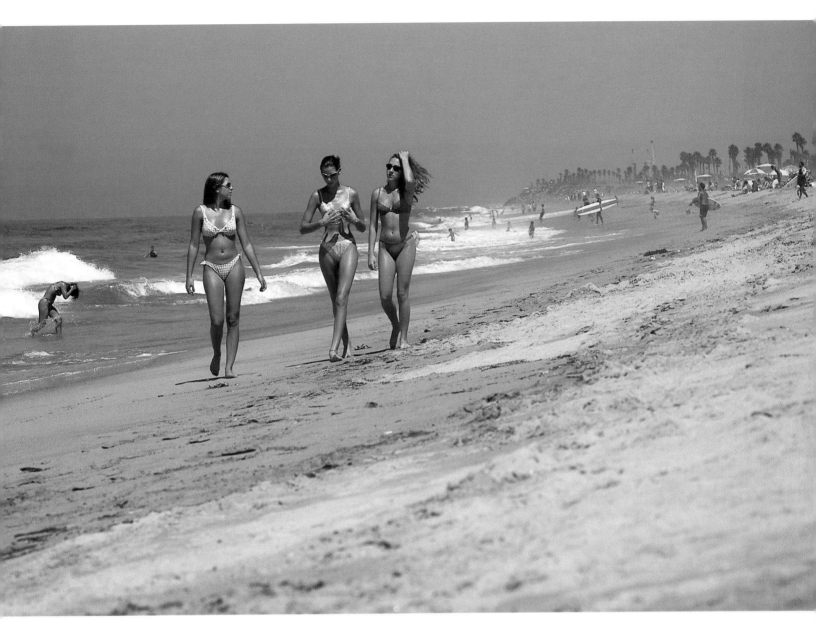

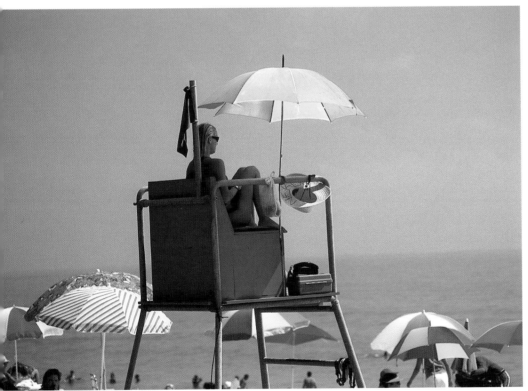

Above:

Huntington Beach, a jewel of a beach along the Orange Coast, is known as "Surf City" among surfing aficionados. *Richard Carroll/California Stock Photo*

Left:

A lifeguard watches over swimmers and a sea of colorful umbrellas at Laguna Beach, the southernmost beach on the Orange Coast. *Richard Carroll/California Stock Photo*

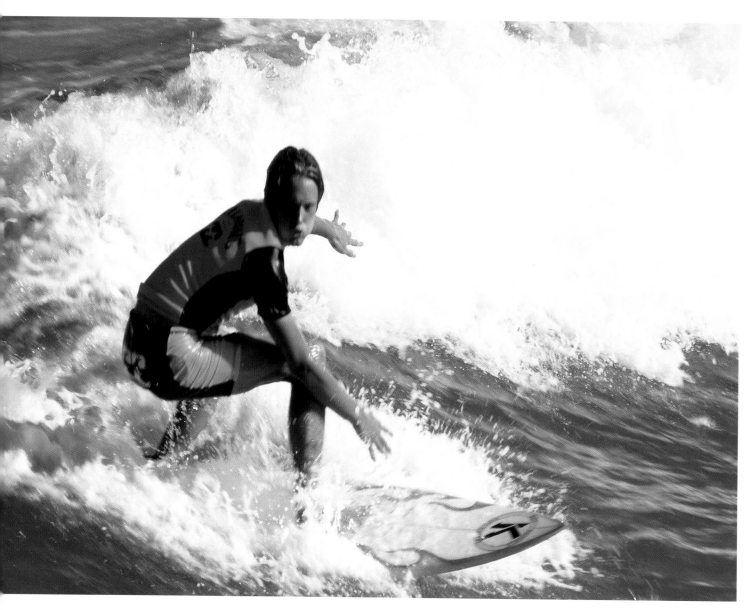

A surfer rides the sea at Huntington Beach, where the waves are said to be the best in the state. The U.S. Open of Surfing is held here each August. *Mark E. Gibson/California Stock Photo*

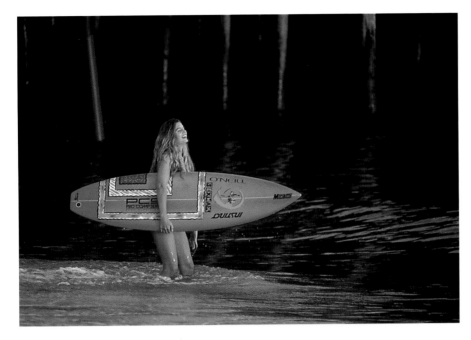

A Santa Monica surfer heads out into the surf in hopes of catching a big wave back to the beach. *Larry Brownstein/California Stock Photo*

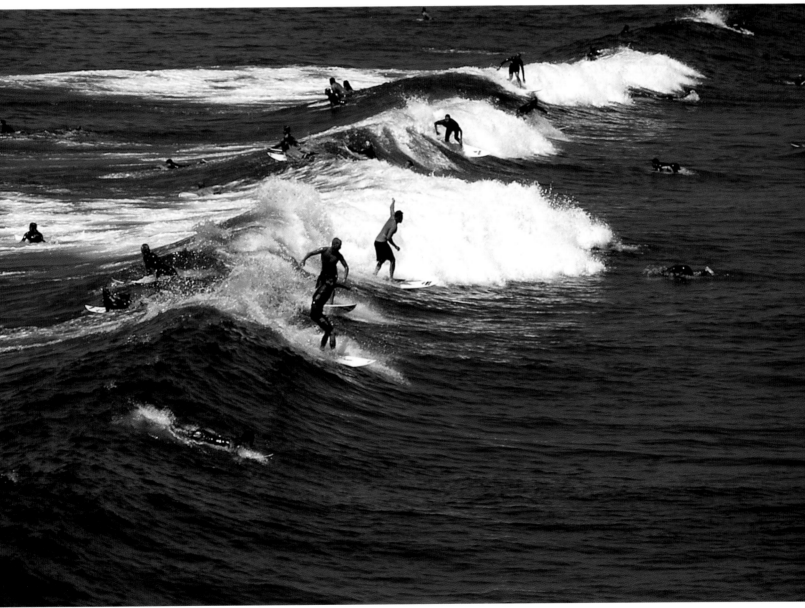

Surfers come in droves to test their skills on the phenomenal Huntington waves. *Richard Carroll/California Stock Photo*

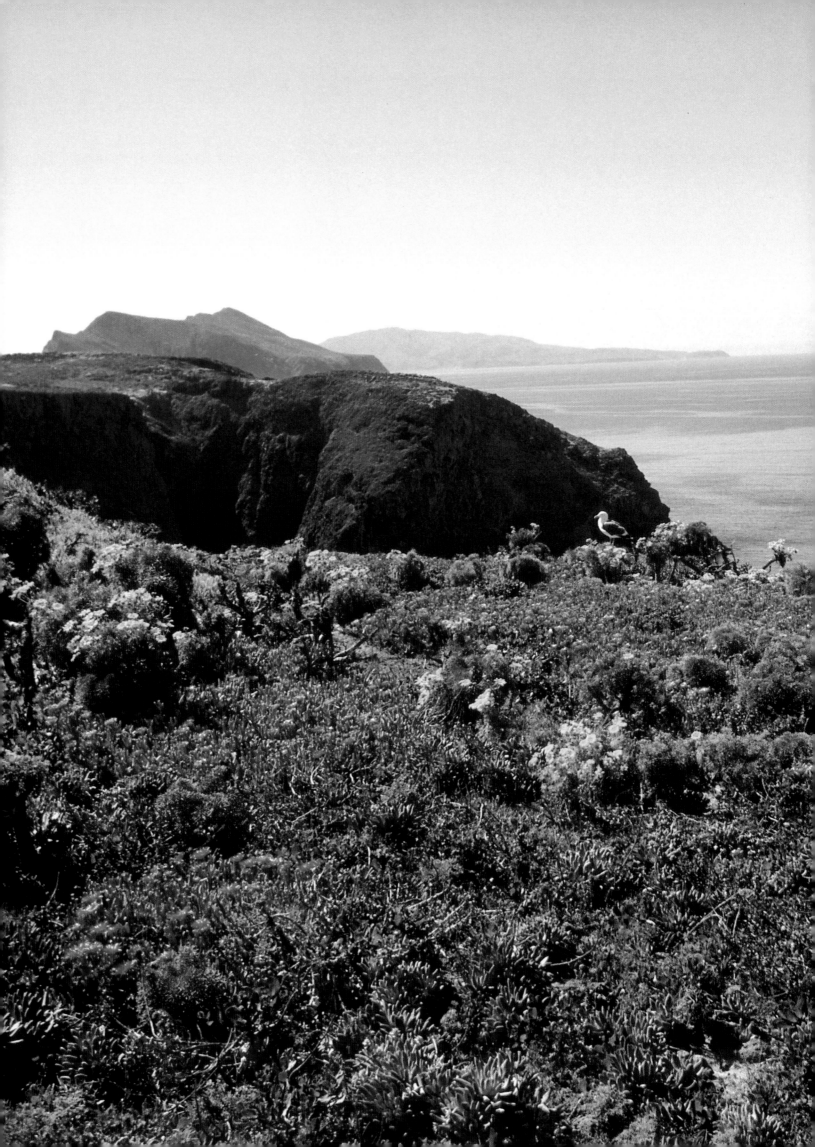

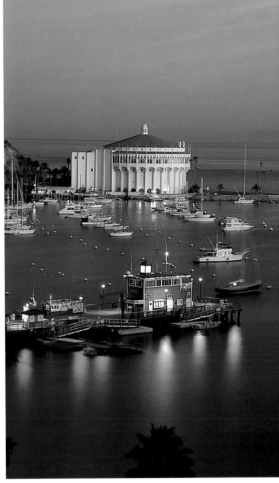

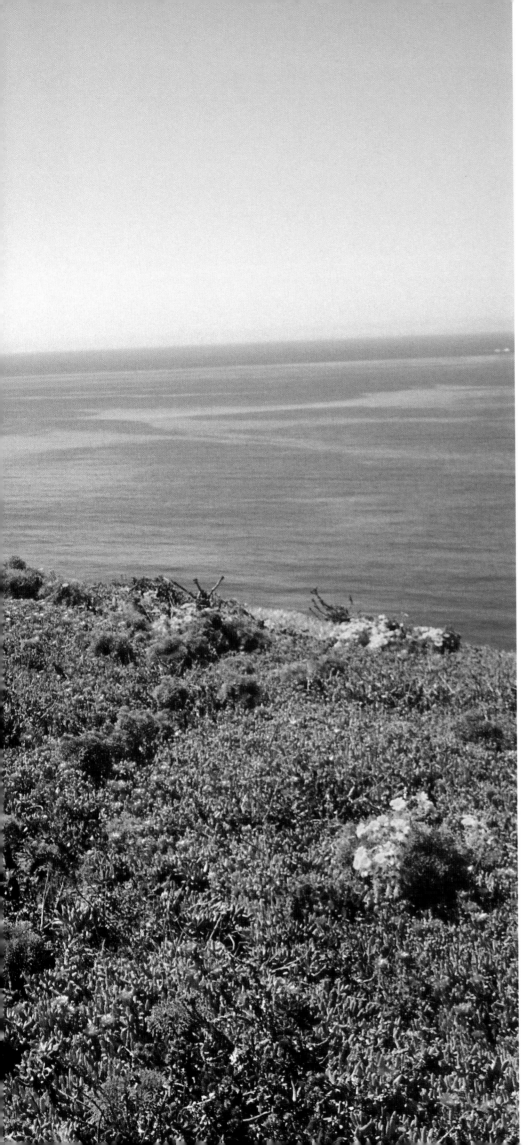

Above:

Catalina Island's Avalon Casino, built in 1929 by William Wrigley of Wrigley's chewing gum fame, stands elegantly along this picturesque bay. The art deco–style building houses a circular ballroom and a movie theater. *Larry Brownstein/California Stock Photo*

Left:

Anacapa Island is one of five islands that make up Channel Islands National Park off the coast of southern California. Pounding surf has chipped away at the volcanic rock of the island to create towering sea cliffs, deep crevices, and caves. *Larry Brownstein/California Stock Photo*

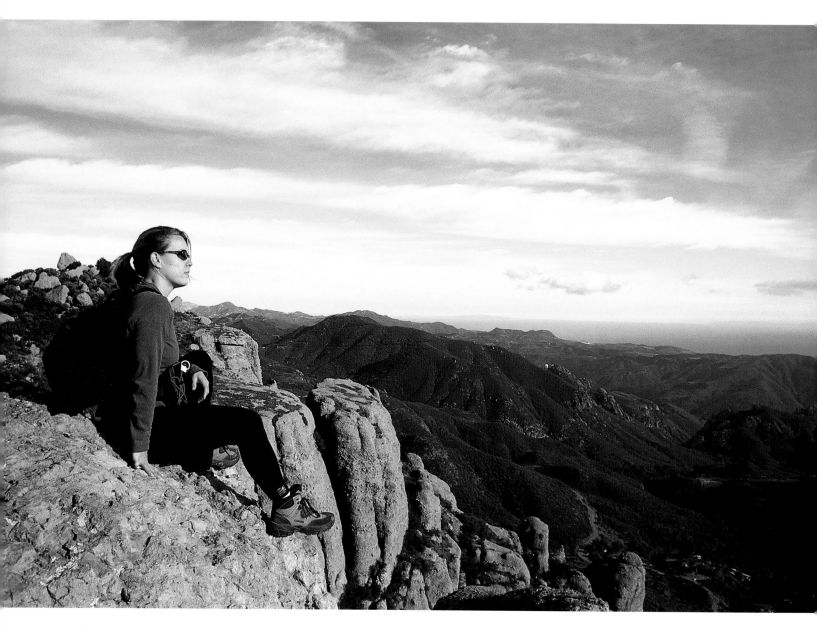

The Santa Monica Mountains National Recreation Area is a hiker's dream, with more than 580 miles of trails for exploration throughout the park. The Backbone Trail traverses 65 miles of rugged landscape. *Peter Bennett/California Stock Photo*

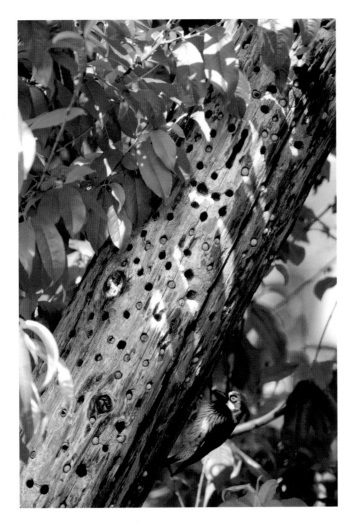

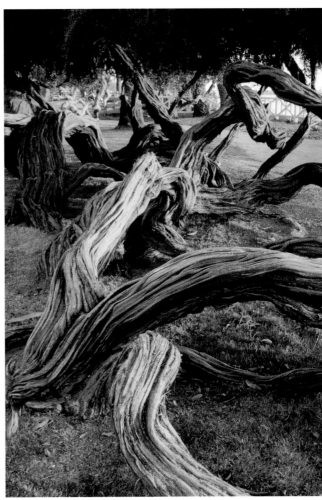

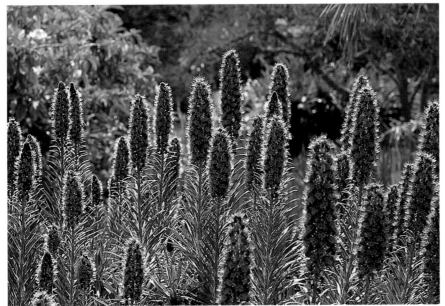

Top left:

An acorn woodpecker drills holes in a dead tree limb to hide acorns, its main source of food, for later consumption. This bird resides in the Solstice Canyon of the Santa Monica Mountains, near Malibu. *Anthony Arendt/California Stock Photo*

Top right:

The twisted limbs and trunks of cypress trees in Palisades Park catch the golden glow of the setting sun. *Anthony Arendt/California Stock Photo*

Above:

Pride of Madeira flourishes on the Palos Verdes Peninsula, an area of headlands, beaches, and secluded coves that divides Santa Monica Bay from San Pedro Bay. *Larry Brownstein/California Stock Photo*

The grounds of Will Rogers State Historic Park offer a lovely view of Los Angeles to the east. Rogers willed his entire 168-acre ranch to the state of California in 1944, including the stables and the house, which is filled with original furnishings. *Peter Bennett/California Stock Photo*

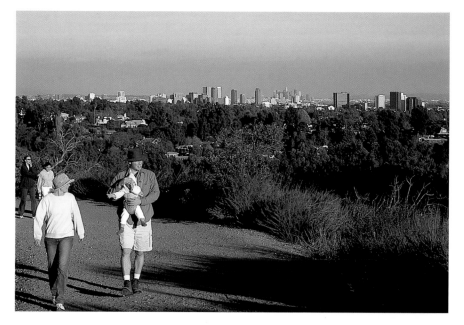

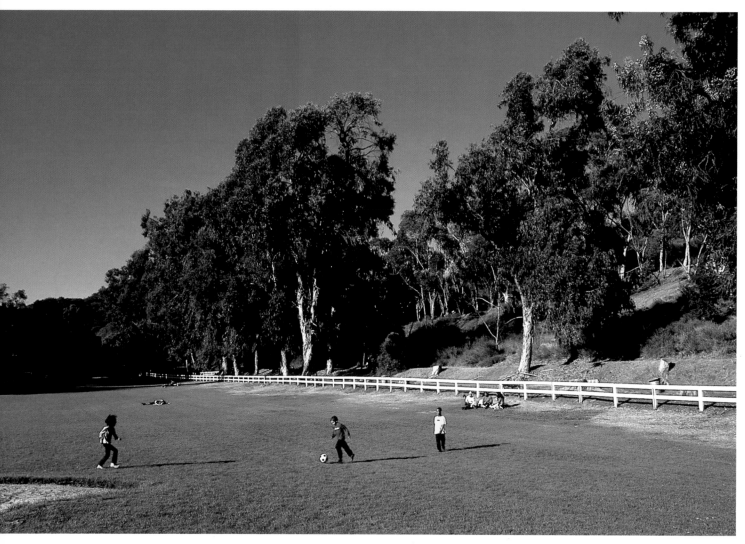

In addition to the many trails for hiking and strolling, Will Rogers State Historic Park has open fields for childhood games and sports. *Peter Bennett/California Stock Photo*

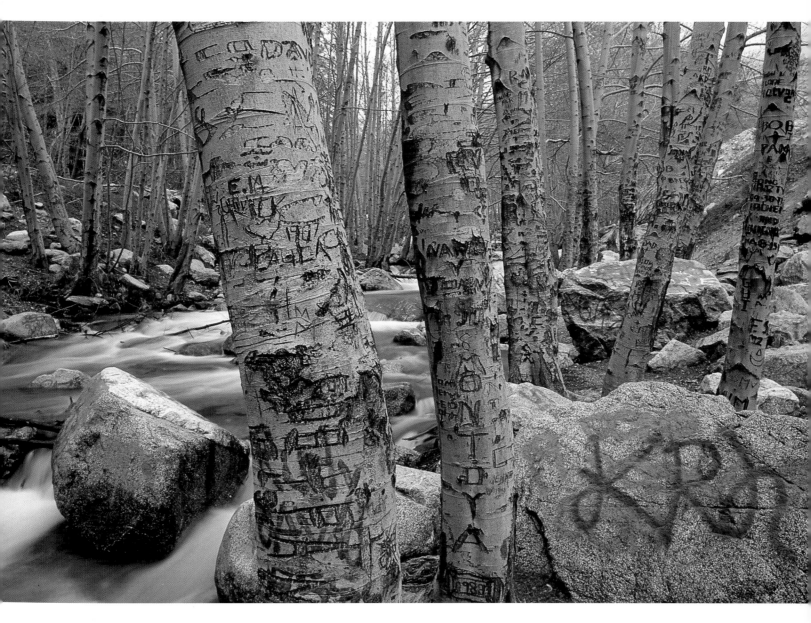

The clash of wild nature and urban reality are apparent in Los Angeles's natural areas. Graffiti and carvings color this peaceful streamside scene in Los Angeles National Forest. *Thomas Hallstein/California Stock Photo*

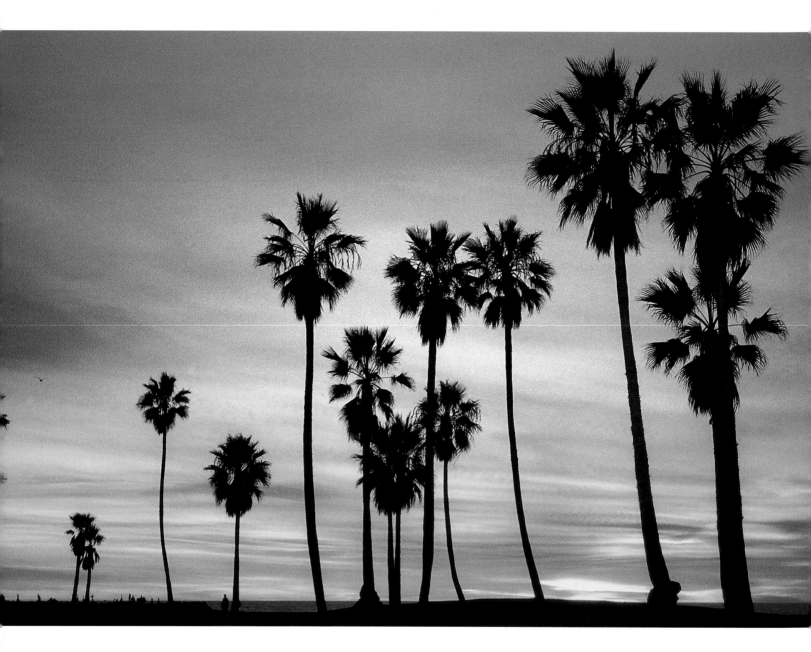

Larry Brownstein/California Stock Photo